BLACK AMERICA SERIES

CHARLOTTE
NORTH CAROLINA

BLACK AMERICA SERIES

CHARLOTTE
NORTH CAROLINA

Vermelle Diamond Ely, Grace Hoey Drain,
and Amy Rogers

ARCADIA

Published by Arcadia Publishing,
an imprint of Tempus Publishing, Inc.
2 Cumberland Street
Charleston, SC 29401

Printed in Great Britain.

Library of Congress Catalog Card Number: 2001012345

For all general information contact Arcadia Publishing at:
Telephone 843-853-2070
Fax 843-853-0044
E-Mail sales@arcadiapublishing.com

For customer service and orders:
Toll-Free 1-888-313-2665

Visit us on the internet at http://www.arcadiapublishing.com

CONTENTS

ACKNOWLEDGMENTS

Many individuals over the years, and especially for this project, shared their personal photographs, newspaper clippings, mementos, and memories with us, and we are grateful to all, including the following: Margaret Alexander, Blondell Carr Sellers, Morris Donald, Lewis Worrell, Annette Johnson Little, Betty Flowe Pierce, Talmadge C. Tillman Jr., Rev. Mildred Feemster Caldwell, Gerson and Daisy Stroud, Marilyn McClain, Carolyn Martin Wilson, Nancy Pethel, Rev. DeGrandval Burke, Alice Haynes Kibler, Jacques D. Kibler III, Constance Sims Grier, Russelle Sims Moore, Thelma McKnight Colston, Kenneth Vinson, Mae Little, John Wallace, Rosa "Bill" Johnson Jones, Adelaide Hunt, Floretta Douglas Gunn, James "Slack" Steele, Edith Ligon Shearin, Carolyn Moore Lee, Jeanette Bowser Hall, Kenneth H. Diamond Jr., Betty Crockett Faulkner, Geraldine and T.B. Haynes, Mary Roseboro Gill, Jim Richardson, Harvey Boyd, Florence Fonvielle, Vivian Harris Burke, Obie Blackwell, Olaf Abraham, Mel Watt, Arthur Griffin Jr., Robert Faulkner, James L. Wright, Annie Mae Dale, Arthur E. Grier Jr., Rufus "Doug" Spears, Rev. Sam Ford, Vernon Herron, Dorothy Broomfield Cherry, Dora Mason, James "Fuzzy" Ferguson, Rev. Barbara Davis Crawford, Valada Adams Tinnin, Doris Asbury, Janie Deese, Charles Jones, Louis Alexander, Zechariah Alexander Jr., Odell and Bertha Brown Robinson, James Webb, Geraldine Powe, Christine Roseboro Bowser, Edna Elder Williams, Tommy Williams, Gene Horton, Burrell Jordan, Francine Carr Jordan, Joseph W. Harper, Charlie and Rose Dannelly, Christopher Polzer, Paula Young, and Calvin Ferguson.

Photographer James Peeler has documented African-American life and events in Charlotte for many decades, and we are proud to include some of his important work in this book. Margaret "Marty" Johnson Saunders tirelessly contacted members of Charlotte's black community, whether they currently live here or far away, and encouraged them to lend us their photos so this book could represent the broadest range of the African-American experience in our community.

We thank Shelia Bumgarner and Dick Ridley at the Robinson-Spangler Carolina Room at the Public Library of Charlotte and Mecklenburg County for their assistance in locating archival photos from the collection. Peter Ridder and Jennie Buckner generously granted us access to the resources of the photographic archive of *The Charlotte Observer*. We also want to thank Mary Newsom and Ann Bryant for their help, and especially Don Williamson, for his technical assistance. The compelling images on the cover are courtesy of the Second Ward High School National Alumni Foundation Inc. (Class of 1929 photo) and Margaret "Marty" Johnson Saunders (Biddle University baseball team photo). We are grateful to the board and members of the Second Ward High School National Alumni Foundation Inc., for their support of this project, and especially to Wright Hunter, Price Davis, Mary Jones, and Charles Redfearn, who helped facilitate the collection of materials for the book.

We thank historian John R. Rogers Jr., of the Charlotte Historic District Commission, whose expert research and interpretation of archival photographs far exceeded his responsibilities as a weekend volunteer.

Michael Rumsch helped us inventory and catalog the photographs, and fellow Arcadia authors Nancy and Frye Gaillard provided valuable research assistance. We are grateful for their work.

Countless school pictures, snapshots, yearbooks, diplomas, portrait photographs, and news clippings that were lent for this book have passed through many hands over the years, as we learned from the names, dates, and other markings that were inscribed on the materials. To everyone who kept and then handed down a treasured memento, we want to express our thanks, even to those people whose names we may never know. Their efforts greatly enhanced the telling of these stories.

INTRODUCTION

"Life was rich," is how one woman remembers it. She, and many other black Americans who grew up in Charlotte, North Carolina, look back on their early years with a bittersweet fondness for a time and place that in many ways seem all but gone.

To be sure, the town that was incorporated in 1768 at the crossroads of two trading paths grew into a city that would claim its place in the evolution of the modern South, and Charlotte's black citizens would play an important role in that growth.

Many people are surprised to learn that urban residential areas of early Charlotte were racially integrated for decades. The city's four "wards" were delineated by Trade and Tryon Streets, and each of those wards developed into a neighborhood with characteristics of its own. Although blacks and whites attended separate churches and schools, citizens of both races often lived in close proximity.

But this began to change after Reconstruction, when legal and social segregation gained a foothold and led to residential segregation as well. It was then that black neighborhoods most definitively established their own business areas, and any imaginary lines between black and white areas of town became clearly understood by all. Photographs from this era show black families, shopkeepers, churchgoers, soldiers, teachers, and other workers living lives that were parallel to those of their white neighbors.

Even before 1900, development was underway in an area called Cherryton, which later came to be known as Cherry. It was the first suburb that offered black families an opportunity for home ownership away from the busy, urban downtown neighborhoods. Other suburbs such as Washington Heights on the city's west side, and Griertown on the east side, followed. In later years, other subdivisions would welcome the black residents that white neighborhoods would not accept.

For much of Charlotte's early history, there was no public education for black children above primary grades. In 1923, the first area high school for black students opened in the Second Ward neighborhood, also known as Brooklyn. Students traveled from every direction to attend, and alumni still remember it as an oasis for the community, where school spirit and a desire for knowledge were strong, and where beloved teachers stepped in to provide for any child in need.

It was during this period that Biddle University, founded to educate black ministers, was renamed Johnson C. Smith University in honor of its benefactor. Soon, other high schools, such as West Charlotte and York Road, would be built to accommodate the growing population. Despite disparities in resources, black students actively engaged in academics, sports, and social activities—in short, everything their white counterparts enjoyed, as photographs from this period show.

When the issue of school integration became a lightning rod for other civil rights issues, Charlotte claimed a place in the national spotlight. On a September day in 1957, four black students became the first to integrate the city's previously all-white schools; in February of 1960, lunch counter sit-ins that had begun only days earlier in Greensboro spread to Charlotte. While these confrontations tested Charlotteans, the dignity and conviction of peaceful protesters could not be denied. In this book, we include photographs seldom seen since they were made to document these seminal events.

But every city that faces the prospect of growth and development must make difficult decisions, and often a city can only fully comprehend the impact of those decisions with the passage of time. In the 1960s and 1970s, as Charlotte modernized, the modest houses and unpaved streets of some black neighborhoods became the subject of intense scrutiny. City

leaders considered such areas blighted and unsalvageable, and set out on a program of urban renewal. Houses, churches, businesses, and schools were torn down in an attempt to revitalize the inner city; among the casualties was Second Ward High School. Residents of these neighborhoods were relocated to different areas of Charlotte.

The cascade of effects proved devastating to those who had always lived, worked, worshiped, shopped, and socialized in the same, familiar places. Even today, many black citizens still claim they would have been content to remain in their family homes and neighborhoods.

"If we were poor, we didn't know it," explains one Charlottean whose neighborhood was razed. Despite their struggles, today's black Charlotteans overwhelmingly maintain an abiding love for the city where they grew up, went to school, embarked on careers, and raised families of their own. Some have distinguished themselves with their political accomplishments. Others who left still come back each year for school reunions. Still more continue to make Charlotte their lifelong home.

This book offers an anecdotal look at black Charlotte through the eyes of the people who lived its history. Volunteers and members of the Second Ward High School National Alumni Foundation, Inc. collected and interpreted photographs from the group's own collection. We chose a wide variety of images—some rare and a few old favorites. But of the hundreds of items that were lent, a number came from private collections and have never before been seen in print, and we are grateful to everyone who shared their time and effort. Although individually a single photograph may portray only one person, place, or event, these images together help to tell the larger story, one that we all share.

<div align="right">

Vermelle Diamond Ely
Grace Hoey Drain
Amy Rogers
June, 2001

</div>

One
PORTRAIT OF A PEOPLE

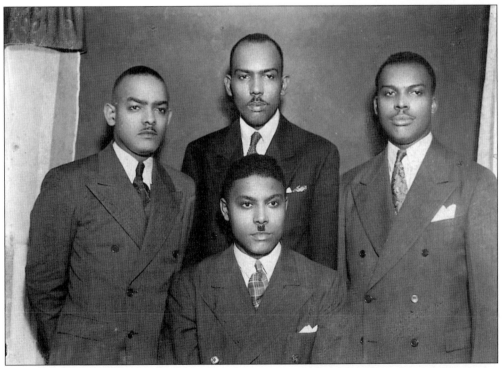

The four Alexander brothers, the sons of Louise and Zechariah Sr., appear as young men in this undated photograph. Zechariah Jr. is seated; behind him from left to right are Frederick, Louis, and Kelly Sr. Another brother, Isaac, died before this portrait was made. The Alexander family rose to prominence in the community as successful business professionals, but they are best known for their civil rights activities and advocacy. (Courtesy of Second Ward High School National Alumni Foundation, Inc.)

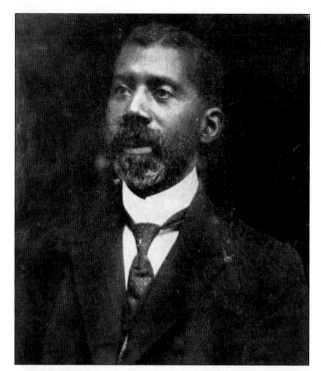

Dr. J.T. Williams was an educator, physician, ambassador, and civic leader. Born near Fayetteville, North Carolina, he came to Charlotte in 1882 as assistant principal of Myers Street School. He was one of the first blacks licensed to practice medicine in the state. In 1898, Williams was appointed ambassador to the West African nation of Sierra Leone. He served in the post until 1907, and died in 1928. (Courtesy of Second Ward High School National Alumni Foundation, Inc.)

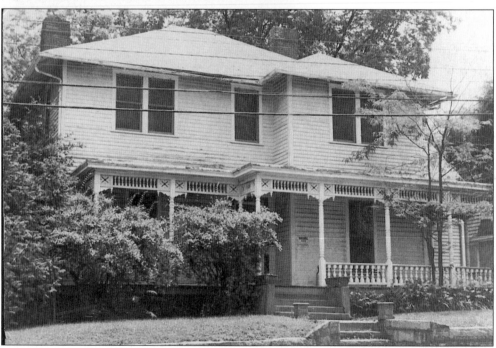

J.T. Williams became one of the earliest black developers in North Carolina. Although he was successful in creating new suburbs on the west side of Charlotte, he maintained his home, shown here, on South Brevard Street in the downtown neighborhood of Second Ward. (Courtesy of Second Ward High School National Alumni Foundation, Inc.)

Sgt. Maj. Zechariah Alexander of the 3rd N.C. Infantry posed for a portrait in his Spanish-American War uniform, *c.* 1898. The commanding figure seen here became the patriarch of the Alexander family, whose future generations would continue to make their mark on Charlotte and beyond. (Courtesy of Margaret A. Alexander.)

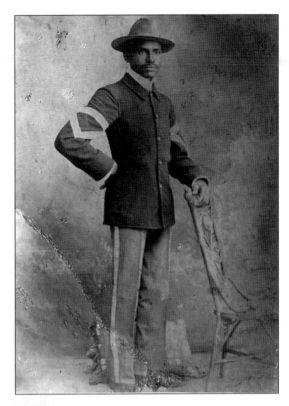

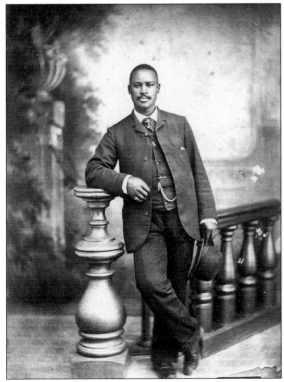

The finely attired gentleman seen in this studio portrait is Col. C.S.L.A. Taylor. He was one of the first black colonels in the U.S. Army, and served in the Spanish-American War. Colonel Taylor operated the National Barber Shop at 19 North College Street, and represented Third Ward as an alderman, elected in 1885. (Courtesy of Jim Richardson.)

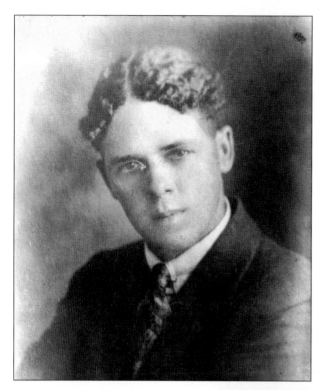

Never was the black community more united than when observing the rituals that surrounded the passing of a loved one. Arthur S. Grier was the patriarch of a family that for generations provided mortuary and funeral services. He founded Grier Funeral Service, the predecessor to Grier & Thompson Funeral Home, and today his descendants operate Family Mortuary, located north of downtown Charlotte. (Courtesy of Arthur E. Grier Jr..)

C.H. Watson, a leader in the black business community, was a developer of Washington Heights. The neighborhood was unique to Charlotte because it was the only streetcar suburb developed by and for black residents. Watson was also the author of *Colored Charlotte*, which when it was published in 1915 celebrated blacks' emancipation and helped promote the new neighborhood that was named for Booker T. Washington. (Courtesy of Second Ward High School National Alumni Foundation, Inc.)

This extremely rare, old photograph is a portrait of four black doctors who practiced in Charlotte in the early 1900s. The gentleman pictured at the top left is believed to be Dr. Alan Wyche, and one physician in front is believed to be Dr. McMillan. (Courtesy of Carolyn M. Wilson.)

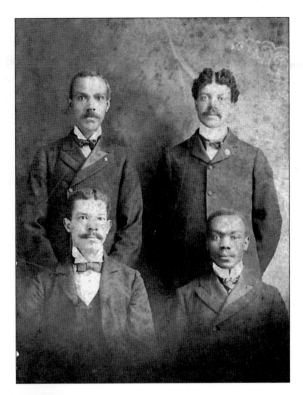

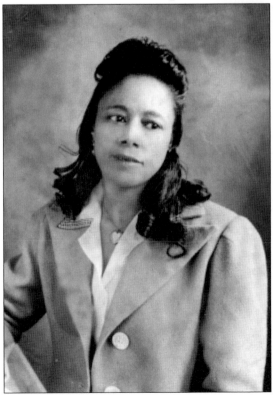

Mollie Duren—Madame Duren, as her customers called her—was an expert seamstress and hairdresser. Born in 1901, she lived to be nearly 100. She was born in rural South Carolina, but moved to Charlotte in the 1920s when she was a young woman and took a job at a beauty shop in Third Ward. She learned to sew on old flour sacks, and continued to make her own clothes when she was well into her 90s. Although she retired in 1978, she remained active for many more years by volunteering for church projects and programs that helped the elderly. (Courtesy of Obie Blackwell).

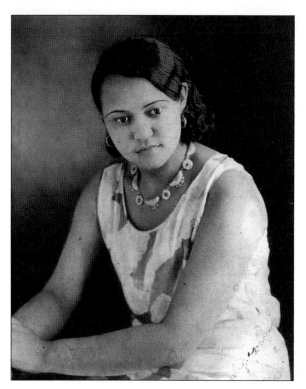

In the early part of the 20th century, job opportunities in the professional world for women, especially black women, were limited. Nursing, cosmetology, and teaching were popular occupations. Myers Street Elementary School teacher Mrs. Ella Vorice Asbury was captured in this pensive portrait that dates back to that time. (Courtesy of Doris Asbury.)

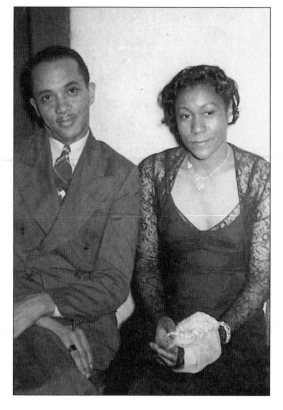

Reuben McKissick owned McKissick's Shoe Repair Shop, which was located on Second Street in the Second Ward neighborhood, which was also known as Brooklyn. His wife, Dr. Willie Mae Rudisill McKissick, began her teaching career when she was a teenager, and went on to teach in Charlotte-Mecklenburg schools for 46 years. As early as the 1920s, they were active in civic affairs, and lent their talents to causes such as the NAACP and the Mecklenburg County Democratic Party. (Courtesy of Grace Hoey Drain.)

Willie Mae Brannon Porter held many prestigious positions during her life. The Carver College graduate became a teacher and community leader who also worked as a reporter for *The Charlotte Post* and *The Afro American Newspaper*. While serving on the National Council of Negro Women, she had tea with three presidents: Roosevelt, Truman, and Johnson. (Courtesy of Marilyn McClain.)

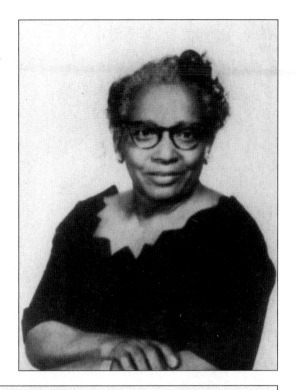

CARVER COLLEGE

CHARLOTTE, N. C.

Certificate of Meritorious Achievement

TO

MRS. WILLIE MAE PORTER

In recognition of outstanding achievements and services in

the community which support the ideals on which

Carver College is based

Dated at Charlotte, North Carolina

This __9th__ Day of June in the Year of Our Lord

Nineteen Hundred and __59__

Director, Carver College

Second Ward High School also served as the home of Carver College after World War II. High school students attended classes during the day, and college students attended at night. The school's motto was "Tall oaks from little acorns grow." Eventually, Carver College became part of what is today's Central Piedmont Community College. (Courtesy of Second Ward High School National Alumni Foundation, Inc.)

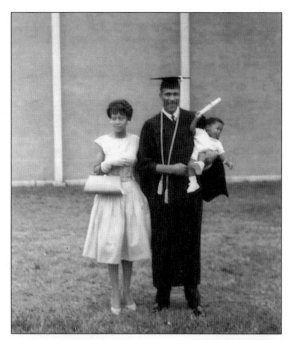

Before he served in the Korean War, before he earned a master's degree from the University of North Carolina at Chapel Hill, and before he became a committee chairman for the NAACP, Charlie Dannelly picked cotton. He grew up in South Carolina but came to North Carolina to attend Johnson C. Smith University and UNC. From 1962 to 1991 he was a teacher and principal, but he is probably best known to most Charlotteans for his service on City Council and in the North Carolina State Senate. His wife Rose is at his side in this graduation snapshot. (Courtesy of Rose Dannelly.)

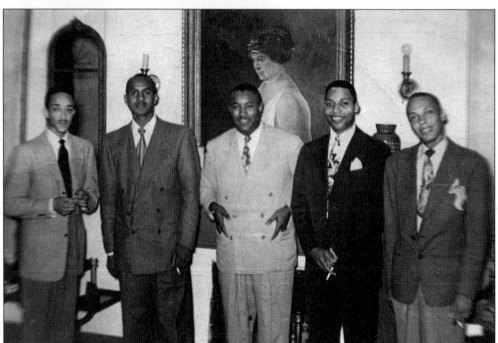

From left to right, Dr. Caesar Black, William "Bill" Oliver, Dr. John Summersette, Gerson Stroud, and Maxwell Mennance are pictured at the West Charlotte home of Lethia Heards Jones Henderson. Henderson is credited with providing a client the first permanent wave to be given in Charlotte, sometime between 1920 and 1930. Through her estate, many thousands of dollars were given to local black charities. (Courtesy of Second Ward High School National Alumni Foundation, Inc.)

Dr. Edward Howard Brown was educated in Charlotte's public schools, then went on to earn multiple degrees—from Johnson C. Smith University, Howard University, and Columbia University. He taught for many years, and is still remembered as one of the organizers of the McCrorey YMCA and a strong supporter of Good Samaritan Hospital. When he retired from teaching, he served as an officer at the U.S. Office of Education. Here he is seen taking part in one of many school-sponsored events. (Courtesy of Vermelle Diamond Ely.)

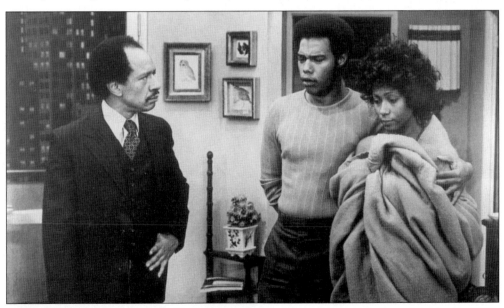

Here is Charlotte native Berlinda Tolbert in her role as "Jenny" in a scene from the popular 1970s television sitcom, *The Jeffersons*. She has also acted on Broadway, performed Shakespeare on stage in London, and appeared on the big screen in films with such Hollywood stars as Richard Pryor, Samuel Jackson, and Harrison Ford. (Courtesy of CBS/Norman Lear Productions.)

West Charlotte High School is situated more than 10 miles from the southeastern Mecklenburg township of Matthews, but in the early 1960s, West Charlotte was one of only two county schools with an art department. Matthews native Harvey Boyd wanted to study art, so he attended school across town at West Charlotte. Although higher education and the jobs that followed took him far away, he came back to his hometown, where he now resides. Boyd, who helped establish Habitat for Humanity in Matthews, was also the designer of the Mecklenburg County seal, which appears in countless uses everywhere from printed materials to signs on motor vehicles. (Courtesy of Harvey Boyd.)

J.S. Nathaniel Tross was editor and publisher of *The Charlotte Post,* minister of Weeping Willow A.M.E. Zion Baptist Church, and a teacher. He was one of the members of the National Negro Newspaper Association who met with President Lyndon B. Johnson in 1965 to discuss racial issues. (Courtesy of Florence Fonvielle.)

Arthur Griffin Jr. is another distinguished native Charlottean. The Second Ward High School graduate is a Vietnam veteran, and is now a specialist in public benefits law, unemployment law, and social security law. His service to the Charlotte-Mecklenburg Board of Education dates back to the 1980s, and he has received numerous commendations from the NAACP, Johnson C. Smith University, the Black Political Caucus, Head Start, and many other organizations. (Courtesy of Arthur Griffin Jr.)

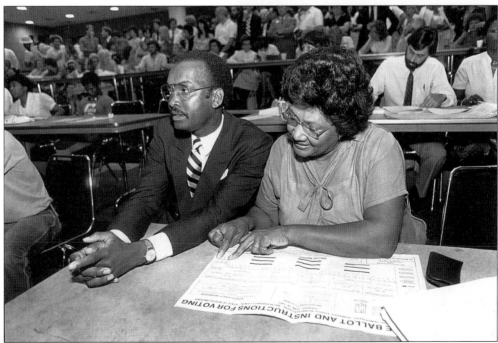

Bishop George Battle and Sarah Stephenson were stalwart leaders of the school board in the years that Charlotte-Mecklenburg grappled with the issue of school desegregation. (Courtesy of Robinson–Spangler Carolina Room, Public Library of Charlotte and Mecklenburg County.)

19

Vivian H. Burke is another former Charlottean with impressive accomplishments. A graduate of Second Ward High School, she earned bachelor of science and master of science degrees. Among the many positions she has held, she was regional manager of the North Carolina Department of Health and Human Resources in Mooresville, near Charlotte. Currently, she is an alderman and mayor pro tem of Winston–Salem, North Carolina. (Courtesy of Vivian H. Burke.)

The Greenville neighborhood of Charlotte was home to a young singer named Wilbert Harrison, who began performing at clubs in the black community. Nothing notable happened in his career until he went to New York in the late 1950s and cut a record of a song called *Kansas City*. Although he was not the author of the old blues song he made famous with its catchy beat; his version is still the one listeners remember most. Harrison died in 1994. (Courtesy of Second Ward High School National Alumni Foundation, Inc.)

"Let's give 'em Mel!" was the campaign cry, and voters did. Melvin L. "Mel" Watt was elected to the U.S. House of Representatives in 1992, and became one of only two black members elected to Congress from North Carolina in the 20th century. A Mecklenburg County native, he was a graduate of York Road High School. He holds degrees from the University of North Carolina at Chapel Hill and Yale University Law School, and has been awarded several honorary degrees as well. (Courtesy of Mel Watt.)

James Franklin Richardson Sr., known to everyone as "Jim," has been active in civic, church, and humanitarian causes for many years—but most of his accomplishments came after his retirement! Among the dozens of awards and commendations he received are those in appreciation for his work on behalf of veterans, minorities, children, and people with disabilities. He has been a member of the North Carolina House of Representatives and Senate, as well as a Mecklenburg County Commissioner. (Courtesy of Jim Richardson.)

Arthur Eugene Grier Jr. is the son and grandson of funeral directors, and he became interested in and began to learn about his family's mortuary business when he was a boy. He was elected to serve on the North Carolina State Board of Mortuary Science, and today he is affiliated with Family Mortuary in Charlotte. (Courtesy of Arthur E. Grier Jr.)

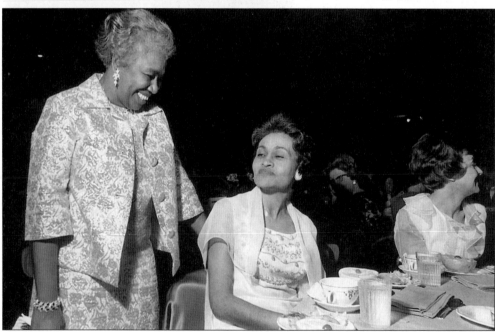

In 1969, Allegra Westbrooks, seen at right, was recognized for her civic contributions to the community. The longtime librarian was congratulated by fellow community advocate, educator Elizabeth Randolph, seen at left. Both women received many commendations throughout their careers. (Courtesy of Robinson-Spangler Carolina Room, Public Library of Charlotte and Mecklenburg County.)

Two
LEARNING FOR A LIFETIME

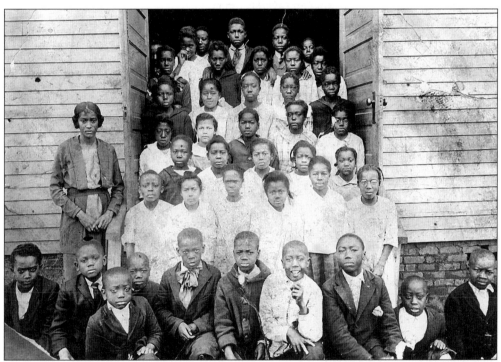

In the years before African-American children were routinely provided a public education, resourceful teachers would open their own schools, often in their own homes. This undated photograph is believed to be Mrs. Lem Long with her class from the one-room schoolhouse that was located on what is now Salem Church Road. (Courtesy of Robinson-Spangler Carolina Room, Public Library of Charlotte and Mecklenburg County.)

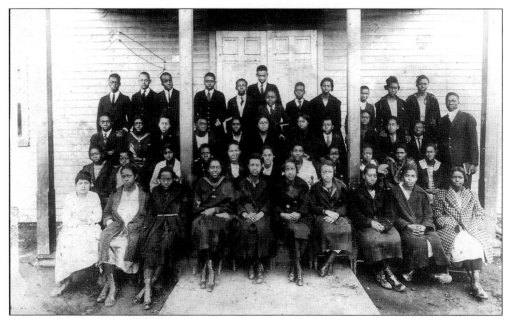

The old Myers Street School was called the "Jacob's Ladder School" because of the staircases that criss-crossed the outside of the two-story building. From the time it was built in 1886 until 1907, no other public graded school in the area enrolled black students. This photograph was most likely made before 1920. The vertical poles in the picture are two supports that held one of the staircases. (Courtesy of Margaret "Marty" Johnson Saunders.)

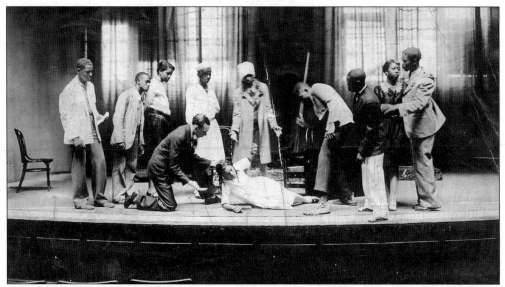

In 1929, as now, students with a flair for dramatic arts took part in school plays. This is a dramatization of a play called *Wild Ginger*, which was staged at Second Ward High School. In the cast were Robert Ballard, Charles H. Turner, William Edward Cornelius, Virginia Gullick, Willie Mae Fleming Springer, Justine Tutt Henderson, Louis Alexander, James Perkins, Margaret Johnson Neal, Rogers McGill, and Gladys Faustina Ellis. (Courtesy of Louis Alexander and Zechariah Alexander Jr.)

The 1884 Biddle Hall is the oldest building and the centerpiece of the Johnson C. Smith University campus. Originally started in a downtown neighborhood, the university soon relocated to its present site on a tract of land donated by the Myers family. First known as Biddle Institute, the college was renamed in honor of a Pennsylvania businessman whose widow, in honor of her late husband, donated over $700,000 to the school in the 1920s. (Courtesy of Second Ward High School National Alumni Foundation, Inc.)

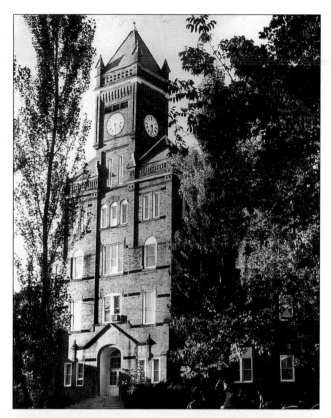

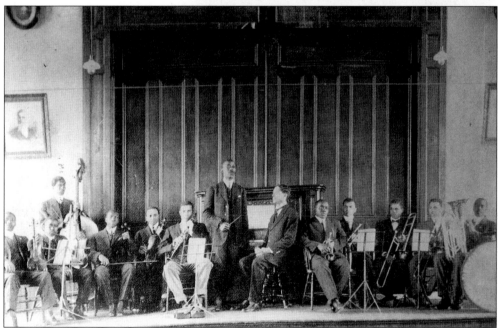

The Johnson C. Smith University orchestra, *c.* 1917, was conducted by Dr. Thomas Long. (Courtesy of Morris Donald.)

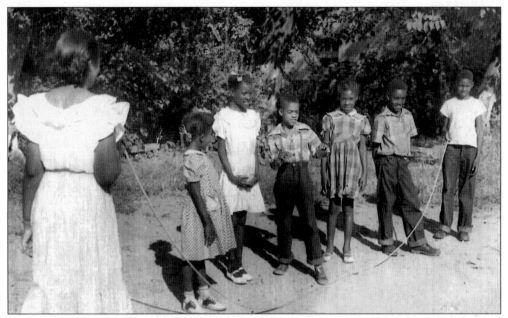

This 1952 photograph of a group of children at play at the Bethlehem Center includes Virginia Warder, Naomi Wade, Ruth Lee Stinson, Henry Fryer, Myrtle Lee Hamlin, Larry White, and Floyd Wallace Jr. The South Caldwell Street recreation center relocated in 1956 and still operates today, serving more than 1,000 people a day at its location a few miles from downtown Charlotte on Baltimore Avenue. (Courtesy of Bethlehem Center.)

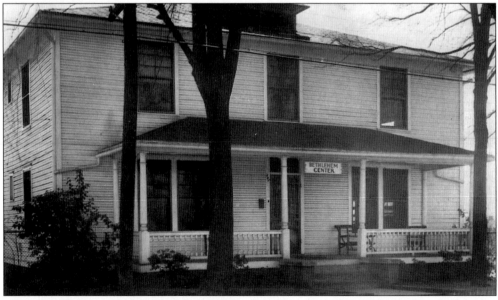

The Bethlehem Center was founded in 1940 to provide a community recreation facility for black residents of Charlotte. Located on South Caldwell Street, it was a church-supported institution that offered daily kindergarten playgroups, sewing and other classes for adults, and summer activities for children. Notably, the Bethlehem Center staff was integrated from the start, and it employed both black and white teachers and volunteers. (Courtesy of Bethlehem Center.)

This original 1947 photograph shows a gathering of the student council at the entry to Myers Street School. Among the students pictured from left to right are Langston Wertz, Grace Hoey Drain, Andrew Walls, Gaynelle Harris, and Bruce Strong. Advisors were Mabel Russell and Rebecca Warner. (Courtesy of Grace Hoey Drain.)

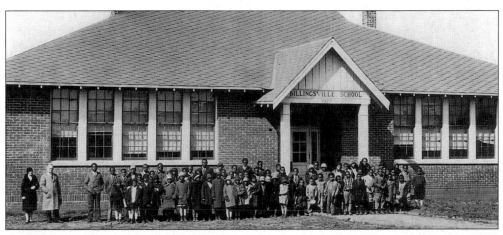

Philanthropist Julius Rosenwald funded the construction of hundreds of schools for black children throughout the South in the early to mid-1900s. A number of them were built in Charlotte and surrounding Mecklenburg County; one was Billingsville School, which was built in 1927. The neighborhood was named for Sam Billings, a black landholder who donated the site for the school. The area has also come to be known as Grier Heights, named for area developer Arthur Grier, whose family was best known for their mortuary business. Although a more modern building now shares the school's site and name, the original building is still in use today as a neighborhood center. (Courtesy of Billingsville School.)

The neighborhood that grew up around Biddle Institute (later Johnson C. Smith University) came to be known as Biddleville. This photo shows Mrs. Leonora Byers' 1941–1942 third grade class of Biddleville School. Although the photo is 60 years old, Carolyn M. Lee recalls the first names of most of her classmates. From left to right are as follows: (first row) Lorene B., Marty ?, Gwen ?, Barb B., Margaret F., Lottie McC., and Frank Alston; (second row) Mary G., Fannie T., Evelyn T., Peggy W., Annie D., and Selena J.; (third row) Thomas C., William J., John E., James D., Sarah McQ., unidentified, and Rosa D.; (fourth row), Walter L., unidentified, and Carolyn M. (Courtesy of Carolyn M. Lee.)

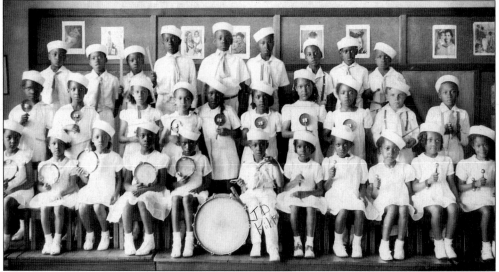

Alexander Street School first opened around 1918, and was located in the First Ward neighborhood of Charlotte. Although the school closed in 1968, Charlotteans who attended still have fond memories of their days as students. This portrait from the 1940s shows the Alexander Street School Rhythm Band. (Courtesy of Jacques D. Kibler III.)

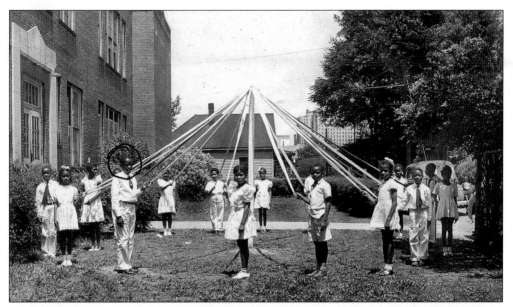

Isabella Wyche was another in-town school that was demolished after Charlotte-Mecklenburg's city and county school systems merged. But the school's demise was more than a decade in the future when this 1946 photograph captured Isabella Wyche students as they took part in Maypole activities on May Day. (Courtesy of Betty Crockett Faulkner.)

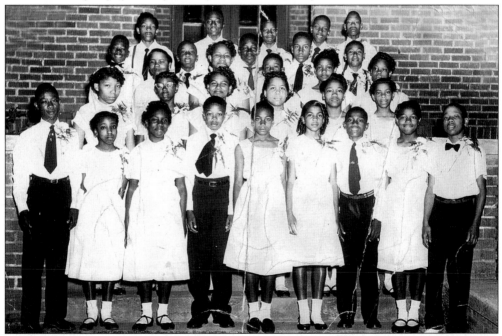

Morgan Elementary School served the Cherry neighborhood, which was developed to offer black families a chance to buy a home away from the noise and crowds of busy urban neighborhoods downtown. Mary Roseboro Gill, who would go on to become a teacher, is standing at the center of the front row in this class picture of the Morgan School seventh grade class of 1953. (Courtesy of Mary Gill.)

29

Marie G. Davis School was named for a prominent teacher and was originally an elementary school for black children who lived in the area south of downtown. This photograph shows Mrs. Leonora Byers Sims's first grade class, probably from the 1950s. Today, Marie G. Davis is a middle school. (Courtesy of Constance Sims Greer and Russelle Sims Moore.)

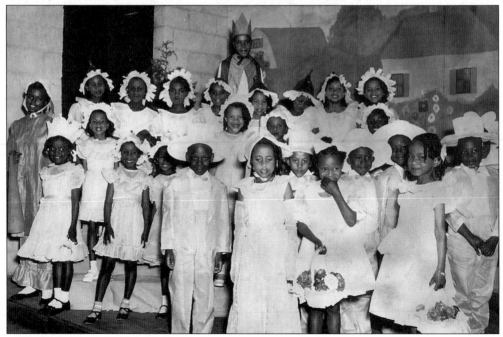

Isabella Wyche Elementary School was the scene for this "operetta" staged by these young performers in the early 1950s. (Courtesy of Betty Crockett Faulkner.)

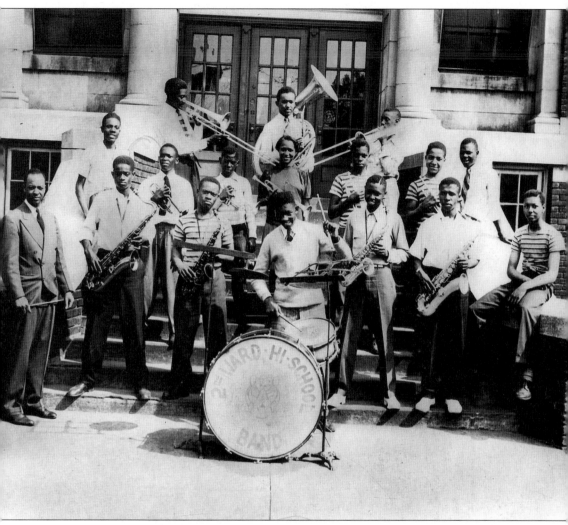

Spirited school rivalries surrounded not only sports, but academics and extracurricular activities as well. This photograph of the Second Ward High School band shows Director Hampton ready to conduct the band that included young musicians Waddell Ellis, Earl Johnson, John Brown, A.B. Gommillion, T.B. Haynes, Marian Vandiver, Robert Lee, William Johnson, and William Yongue. (Courtesy of T.B. and Geraldine Haynes.)

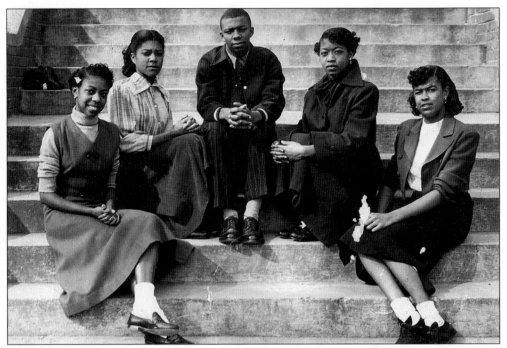

In 1951, the student body of West Charlotte High School elected their fellow classmates as officers of the student council. Seated on the school steps are, from left to right, Mabel Haynes, Mildred Smith, William Johnson, Rosa Davis, and Carolyn Martin. (Courtesy of Carolyn Martin Wilson.)

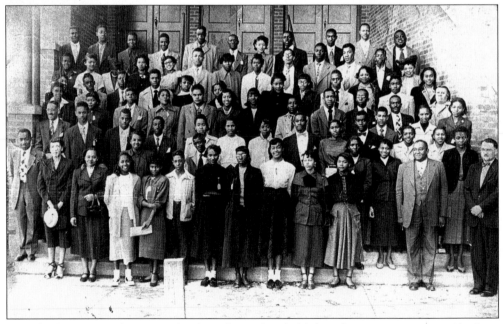

In 1949, the state student councils of North Carolina held their first meeting at West Charlotte High School. This professionally attired group of student leaders from across the state posed for a portrait on the steps of the school's auditorium. (Courtesy of Jeanette Bowser Hall.)

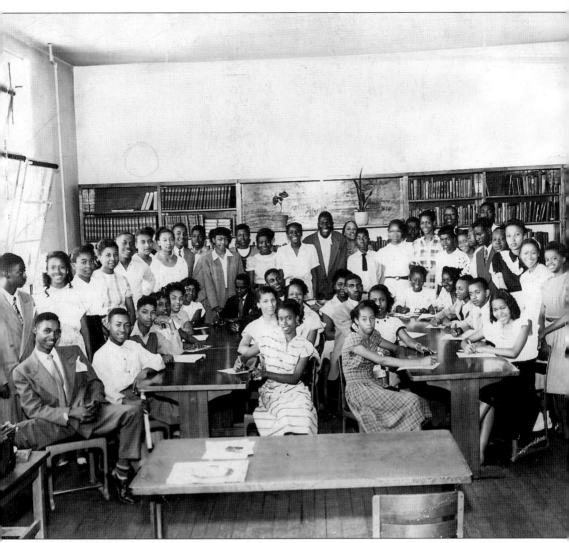

The future looks bright for this group of poised student council members from Second Ward High School. Included in the group photograph are James Wright, Osie Barber, Theodore Gaither, Mercia Wilkins, Walter Brown, Clara Davis, Blondell Carr, Queen Thompson, Harriet Young, Howard Campbell, Annie Mae Salley, Venetta Redfern, Robert Yongue, and Mattie Gill. (Courtesy of Doug Spears.)

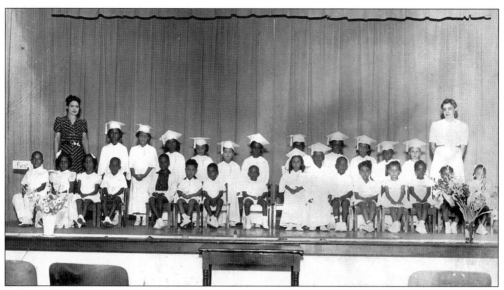

Graduation is a memorable event, whether the students are adults who are ready to take their place in the world, or young children moving from kindergarten to grade school. This portrait of the graduating kindergarten class of Fairview School is believed to date to 1941. (Courtesy of Alice Haynes Kibler.)

Isabella Wyche School, situated in Charlotte's Third Ward neighborhood, was named for the first black woman to serve as principal in the Charlotte-Mecklenburg school system. Members of the faculty included in this portrait from left to right are (front row) Cora Booton, Lillian P. Massey, Emma Duren, Mary Lee Henderson, Louise K. Hall, Jean Moreland, Nurse Sanson, and B.D. Moore; (middle row) Geraldine Daniels, Emma Dunlap, Rose Pitts Smith, Robert Reeder, Zenobia Hagar, Grace Solomon, and Secretary Tinkers; (back row) Ernestine Steward, Grace Wiley, Margaret Patterson, Gladys Moreland, Bernice Brown, Frances Nash, Katherine Bowser, Eddington Houston, and Lucille Hamilton. (Courtesy of Betty Crockett Faulkner.)

Mr. Alexander Byers was the principal seen standing behind the faculty of Amay James Elementary School in this undated photograph. The teachers are identified only by their first names; from left to right are Dottie, Helen, Betty, Jane, Owens, Sarah, Isher, Helen, and Cat. (Courtesy of Grace Hoey Drain.)

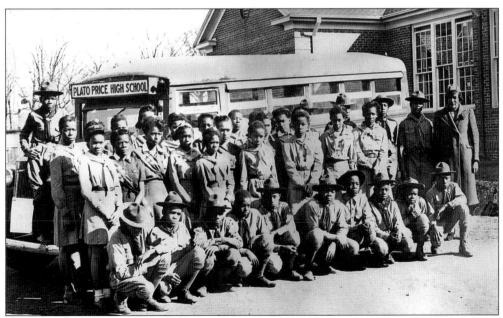

Plato Price High School was located in western Mecklenburg County, and originally enrolled students of all grade levels. Eventually, the separate city and county school systems merged, and the old Plato Price school building was torn down. (Courtesy of Grace Hoey Drain.)

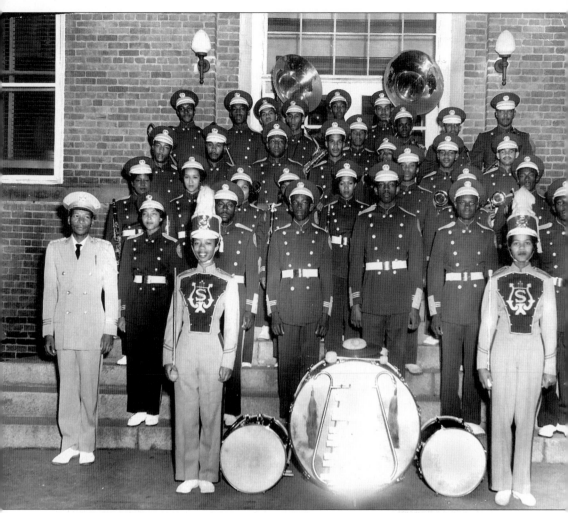

One of the highlights of any parade in Charlotte has long been the Johnson C. Smith University Marching Band. This is the 1958–1959 band, under the direction of Daniel Owens, who appears at the left of the photo. (Courtesy of Morris Donald.)

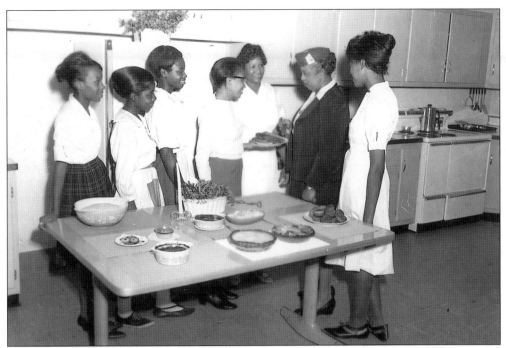

Despite a lack of resources compared to those afforded white students, Charlotte's black students nonetheless received a quality education at their own schools, where chemistry, English, French, history, language, math, music, and science were taught. Here, Dorothy Flagg's home economics students meet with Nurse Anderson at Second Ward High School. (Courtesy of James Peeler.)

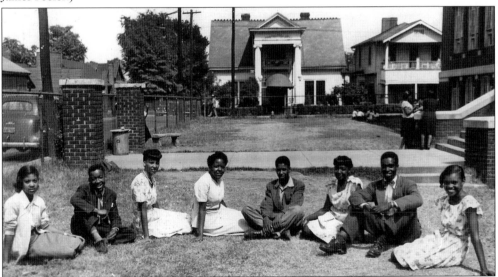

Those who believed that black, in-town neighborhoods were no more than blighted slums need look no further than this photo to learn otherwise. Second Ward High School can be seen at the far right of the photo, flanked by large dwellings that anchor adjacent First Street. Student council officers posed on the school's lawn for this informal photo that is a snapshot of a typical day at the school. (Courtesy of Blondell Carr Sellers.)

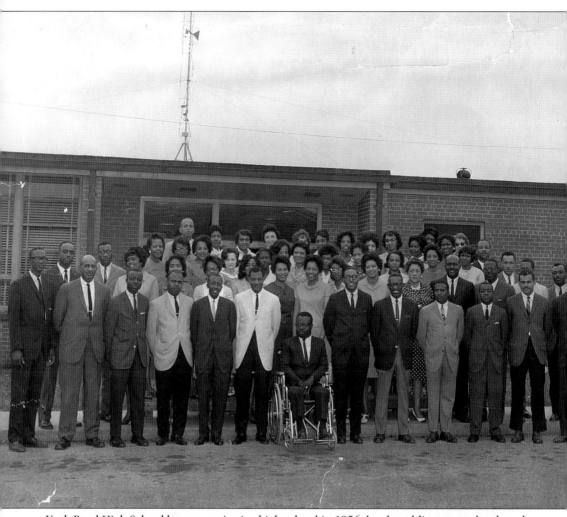

York Road High School began as a junior high school in 1956, but by adding upper level grades, it had become both a junior and senior high school by 1959. Its name is a bit misleading, since the school is not actually located on York Road, but officials thought the name would help residents find the school more easily. This is a photograph of the 1966 York Road Junior-Senior High School Faculty. (Courtesy of Gerson Stroud.)

Ladies from the Johnson C. Smith University German Club enjoy an outing on the school campus in this undated photograph. (Courtesy of Margaret "Marty" Johnson Saunders.)

Sometimes it's the casual snapshots rather than the formal portraits that people cherish most. Talmadge Tillman, pictured in this group, left Charlotte after his graduation from high school and obtained a doctoral degree in California. Even though it has been nearly a half-century since he made his home here, he comes back each year for reunions. This 1942 photo includes from left to right (kneeling) M. Wardlaw, N. Barrett, and O. Woodard; (standing) R. Alexander, J. Maxwell, T. Tillman, and M. Stroud. (Courtesy of Talmadge C. Tillman Jr.)

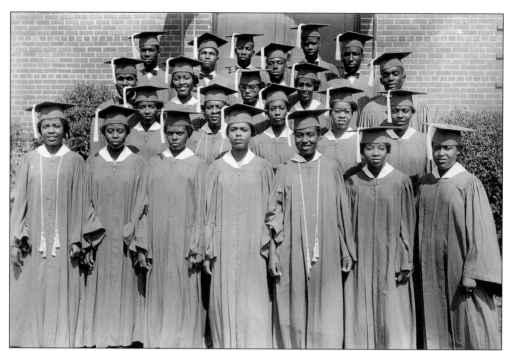

Here is the class of 1957 from J.H. Gunn School. Located in eastern Mecklenburg County, it was named for James Henry "Jimmy" Gunn, a popular musician and teacher. Originally, the school enrolled students in all grades from elementary to high school, and although it closed at one time, it has reopened and is now J.H. Gunn Elementary School. (Courtesy of John Wallace.)

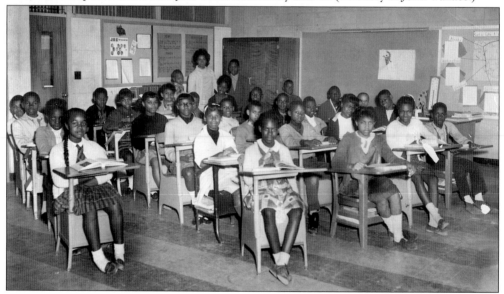

Even before the sprawling development that in one way defines Charlotte today, many residents made their homes in early suburbs and rural areas that surrounded the city. Until 1960 there were separate city and county school systems, which then merged into one consolidated system. Torrence Lytle was one of the schools in Mecklenburg County, located in the northern part of the county. Shown here is teacher Mary Gill's fifth grade class of 1965. (Courtesy of Mary Gill.)

40

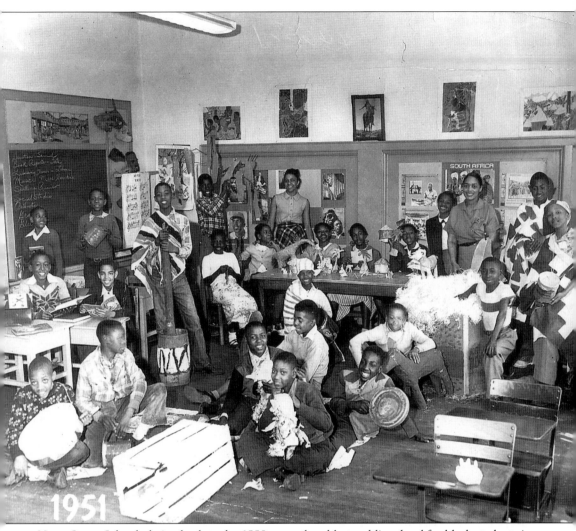

Myers Street School, dating back to the 1880s, was the oldest public school for black students in Charlotte. By some accounts, by the 1940s it had the largest number of black students of any school in North Carolina, but Myers Street School was torn down in the 1960s. The active and smiling children pictured here in this 1951 group photo include Thomas Geiger, Leroy Davis, Olaf Abraham, Walter Holtzclaw, Ben Tate, Ruth Dunn, Altavia Ray, Johnnie Mae Glover, Henry Johnson, James Ryans, Henry Ford, Samuel Ervin, Ralph Nell, Julia Hoffman Sanders, and Matilda Spears. (Courtesy of Olaf Abraham.)

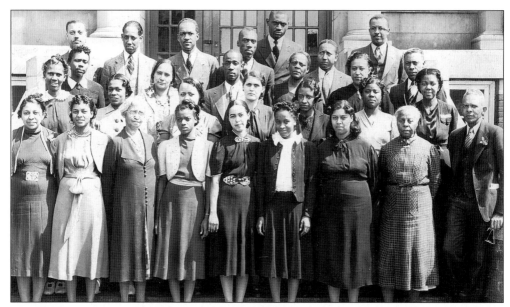

Mr. J.E. Grigsby, at the far right of the photograph, was principal of Second Ward High School from 1931 to 1957. This 1930s-era faculty portrait depicts, from left to right, (first row) Marguerite M. Adams, Mrs. M.D. Beckwith, Mrs. Stinson, Mary Pettice Spivey, Myrtle Brodie, Alene McCorkle, unidentified, and Hannah Stewart; (second row) Louise Spears Meadows, Mrs. W.W. Carson, Pearl Phillips, unidentified, Selena Robinson, Mattie Hall, and Charlotte Norwood; (third row) Laura Spears Malone, Mrs. M.T. Archer, unidentified, Mrs. Banner, and unidentified; (fourth row) Eric Moore, Kenneth Diamond Sr., Edward Brown, Louis Levi, Oscar Clarke, and Fred Wiley; (top row) Mr. Farmer and Howard Moreland. (Courtesy of Daisy Stroud.)

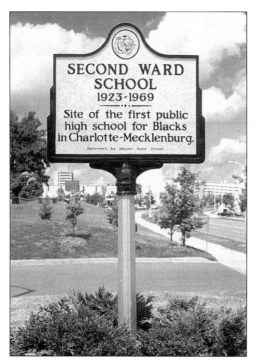

Second Ward High School, the first high school for blacks in the city, educated many of Charlotte's black citizens during its 46-year history. Although the school no longer stands, affection for both the school and what it meant to the community continues today. Alumni and friends worked with the Charlotte-Mecklenburg School Board and the City of Charlotte to erect this marker as a reminder of the school's historic role in shaping modern Charlotte. (Courtesy of Second Ward High School National Alumni Foundation, Inc.)

Three
THE SOUL OF
BLACK CHARLOTTE

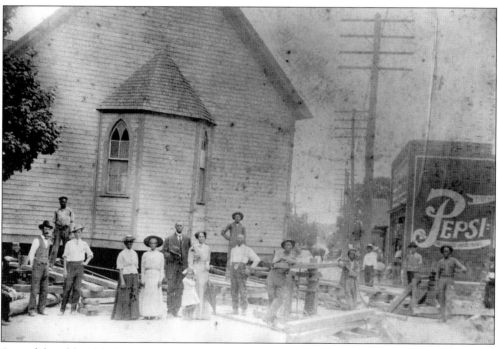

One of the oldest black congregations in Charlotte, the Little Rock A.M.E. Zion Church began in the Third Ward area but was later relocated—literally—to Myers Street in First Ward. Here, the church is being moved in 1911. More than one Charlottean confirms that a member passed away during the several days it took to move the church, and the funeral was held in the church while it was between its old site and its new one. (Courtesy of Floretta Douglas Gunn/Robinson-Spangler Carolina Room, Public Library of Charlotte and Mecklenburg County.)

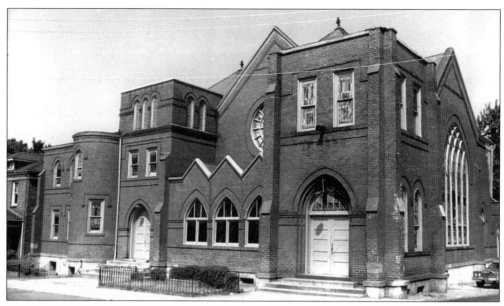

The old First Baptist Church was located at 1020 South Church Street. It was Charlotte's first Baptist church for blacks, organized in 1867 by former slaves. The building pictured here was dedicated in 1911 but demolished, along with a dozen others, when the in-town black neighborhoods were redeveloped in the 1970s. The congregation moved and opened a new church, known as First Baptist Church West, on Oaklawn Avenue. (Courtesy of Minnie McKee.)

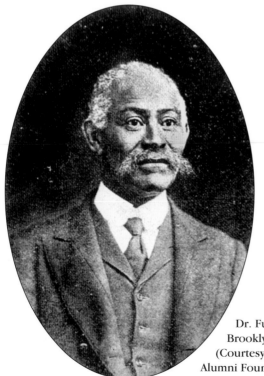

Dr. Furman L. Brodie served as pastor of Brooklyn Presbyterian Church during the 1920s. (Courtesy of Second Ward High School National Alumni Foundation, Inc.)

Although early in the 20th century the ministry was generally considered to be the realm of men, there were women who preached the gospel even if they did not have congregations of their own. Evangelist M.E. Davidson lived at 512 South Caldwell Street in the Second Ward neighborhood. (Courtesy of Vernon Herron.)

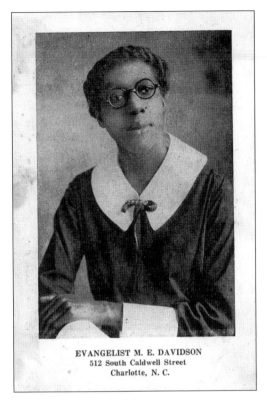

EVANGELIST M. E. DAVIDSON
512 South Caldwell Street
Charlotte, N. C.

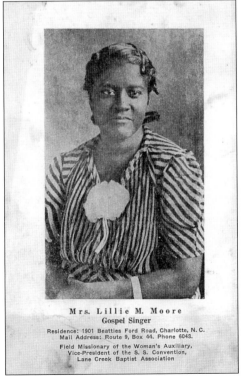

Mrs. Lillie M. Moore
Gospel Singer

Residence: 1901 Beatties Ford Road, Charlotte, N. C.
Mail Address: Route 9, Box 44. Phone 6043.

Field Missionary of the Woman's Auxiliary,
Vice-President of the S. S. Convention,
Lane Creek Baptist Association

Mrs. Lillie M. Moore was a gospel singer who lived at 1901 Beatties Ford Road, west of downtown Charlotte. This handbill, probably from the 1930s, explains she was a field missionary of the women's auxiliary of the Lane Creek Baptist Association. If you wanted to reach her by telephone, a simple four-digit number—6043—would connect you; three-digit telephone exchanges would not be used until after World War II. (Courtesy of Vernon Herron.)

This group of young people poses at the entrance to Friendship Baptist Church on Brevard Street in the Second Ward neighborhood, also known as Brooklyn. Rev. Coleman Kerry and his wife, Marizetta, are at the far left, rear. Like a dozen others, this church was lost to urban renewal. (Courtesy of James Peeler.)

St. Paul Baptist Church stood on McDowell Street and was home to one of the many black congregations that were displaced by Charlotte's urban renewal (Courtesy of James Peeler.)

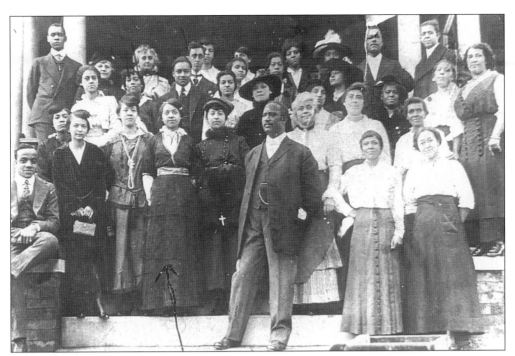

Bishop George Wylie Clinton, shown in the foreground with his wife Marie at his left shoulder, hosted Christmas holiday receptions that were the highlight of the season for Charlotte's black community. This photo is believed to have been taken during a World War I-era gathering, c. 1918. (Courtesy of Second Ward High School National Alumni Foundation, Inc.)

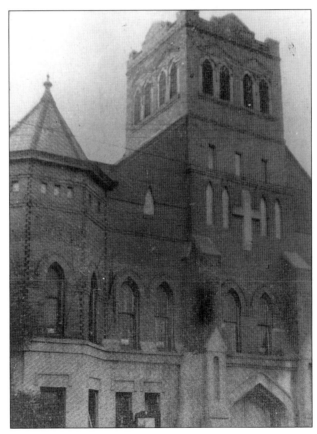

When urban renewal projects were implemented in the black neighborhoods of downtown Charlotte, more than homes and businesses were lost. Over a dozen churches were torn down as well. Clinton Chapel A.M.E. Zion Church was located at 419–421 Mint Street, in the Third Ward neighborhood. (Courtesy of Second Ward High School National Alumni Foundation, Inc.)

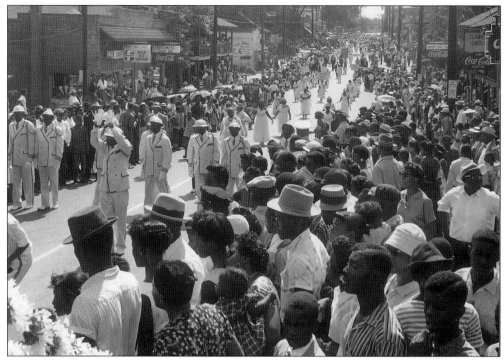

Make way for the House of Prayer parade! Each September, Bishop C.M. "Sweet Daddy" Grace, known for his lavish lifestyle, would visit Charlotte to hold revival meetings and baptisms. The parades staged in his honor were legendary for their huge, enthusiastic turn-outs. (Courtesy of Robinson-Spangler Carolina Room, Public Library of Charlotte and Mecklenburg County.)

The charismatic Bishop C.M. "Sweet Daddy" Grace was founder of the United House of Prayer for All People. Daddy Grace is seen here on a parade float during one of his yearly visits to Charlotte. He spent more than 50 years as a minister, and when he died in 1960, his body was returned to Charlotte for one last parade—this one a funeral procession. (Courtesy of Robinson-Spangler Carolina Room, Public Library of Charlotte and Mecklenburg County.)

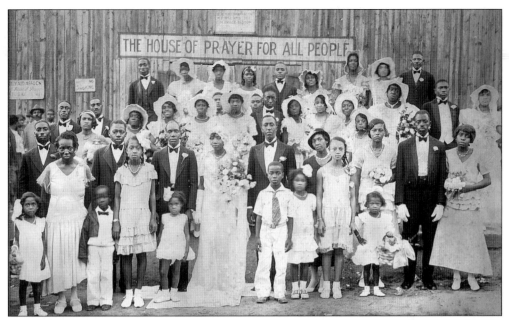

Bishop C.M. "Sweet Daddy" Grace will always be associated with Charlotte. It was here that the preacher gained a strong foothold in establishing his church, the United House of Prayer for All People. Although this wedding portrait from 1927 may appear quaint and old-fashioned, the denomination continues to attract new members today. It has more than 100 congregations, and has its headquarters in Washington, D.C. (Courtesy of Rev. Sam Ford.)

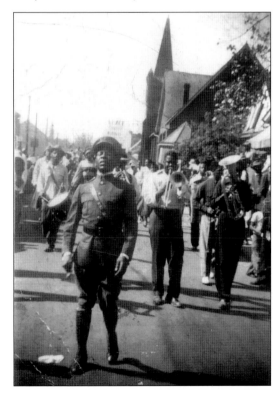

Capt. Shedrick Ford was a "Grace Soldier," which meant he was an active member of the Daddy Grace entourage. When the Daddy Grace parades came through Charlotte, these soldiers stepped and strutted for the crowd magnificently. (Courtesy of Rev. Sam Ford.)

49

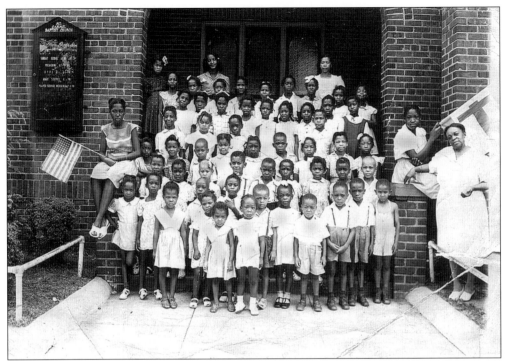

Vacation Bible School was as much a Southern tradition as summer itself. Here are students of the Mt. Carmel Baptist Church, pictured in a portrait believed to have been made in 1945 or 1946. (Courtesy of Mae Little.)

Many older church congregations established prior to Charlotte's recent population and economic boom may have seemed small in comparison, but regardless of size the church has always played a crucial role in Southern life. This *c.* 1947 photograph shows the Mt. Carmel Baptist Church Sunday School teachers. (Courtesy of Mae Little.)

St. Paul's Presbyterian Church dates back to the period immediately after the Civil War. The congregation's singers in the early 1950s are, from left to right, (first row) Mrs. G.C. Moore, Mrs. R.W. Davis, George Wallace Jr., Miss Sarah McClelland, John H. Lineberger, and Mrs. Geneva W. Henderson; (second row) Paul H. Cathey, Mrs. Johnnye J. Lineberger, the Misses Willie B. Wallace, Sarah E. Wallace, Johnnye V. McClelland, Carrie M. McClelland, and Excell Smith; (third row) Mrs. Rosie L.C. Moore, Mrs. Luciells J. Smith, Mrs. Obbie G. Carter, Miss Ollie M. Campbell, and Mrs. Nell W. Cathey; (fourth row) George S. Wallace Sr., Myrtis O. Stewart, William R. Henderson, Floyd Carter, and Mark Carter. (Courtesy of John Wallace.)

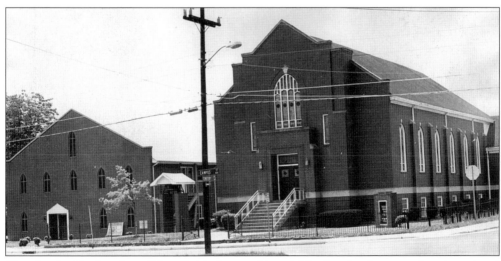

Churches in Charlotte's traditionally black west-side neighborhoods often served as the cultural center of the community. Gethsemane A.M.E. Zion Church stands at the corner of Campus and Cemetery Streets, near the Johnson C. Smith University campus. (Courtesy of Adelaide Hunt.)

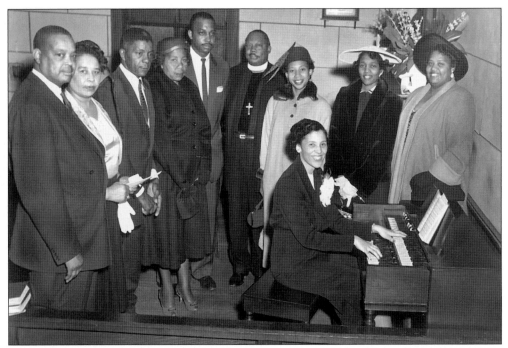

This photo at Myers Tabernacle A.M.E. Zion Church shows, from left to right, Ed Roper Sr., Arlena Roper, Sam Gill, Adelaide Gill, Ed Roper Jr., Rev. Paul F. Thurston, Margaret Gill, Willie B. Roper, Wilhelminia Roper, and organist Blondell C. Sellers. (Courtesy of Blondell Carr Sellers.)

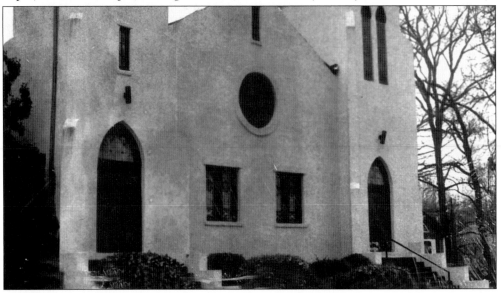

Located in the heart of the Cherry neighborhood southeast of downtown Charlotte, Myers Chapel A.M.E. Zion Church was initially organized in 1901. The Myers family, who owned a large farm, donated the land for the current church building, which was completed in 1921. The Myers' family farm would eventually be developed into the Myers Park neighborhood, which adjoins the smaller Cherry community that pre-dates it. (Courtesy of Second Ward High School National Alumni Foundation, Inc.)

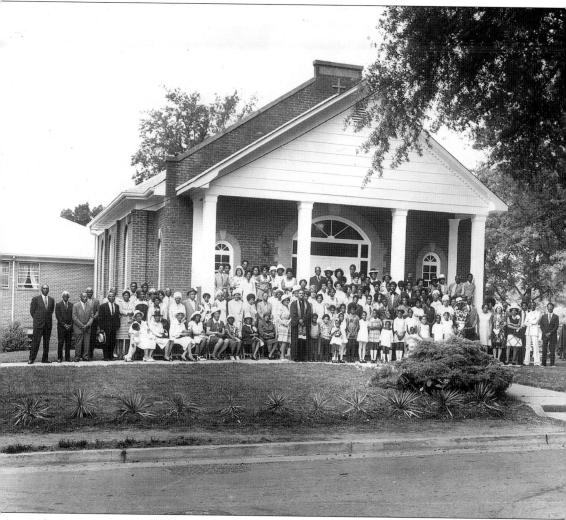

Early worshipers in the Grier Heights neighborhood met at the home of Naomi Drennan until the house became too small to accommodate their growing number. Then, in the early 1940s, they began to gather at the Billingsville School. Mr. and Mrs. Arthur Grier purchased and donated the land where the church would be built. That church is Grier Heights United Presbyterian Church, pictured here in 1967. (Courtesy of Second Ward High School National Alumni Foundation, Inc.)

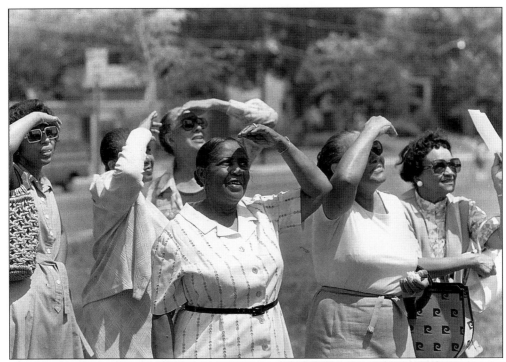

Minnie Jackson McKee, Cecilia Jackson Wilson, and Mildred Aldridge admire the new bells installed at First Baptist Church West. The original First Baptist Church was located in the Third Ward neighborhood. (Courtesy of Second Ward High School National Alumni Foundation, Inc.)

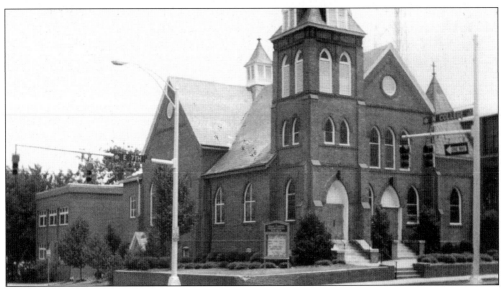

Modern-day photos of downtown black churches are truly rare, since so many were demolished and their sites redeveloped. This church, First United Presbyterian, is located at the corner of College and Seventh Streets. It has survived as an active black parish in the center city. (Courtesy of Betty Flowe Pierce.)

Four
LIFE IN THE CITY

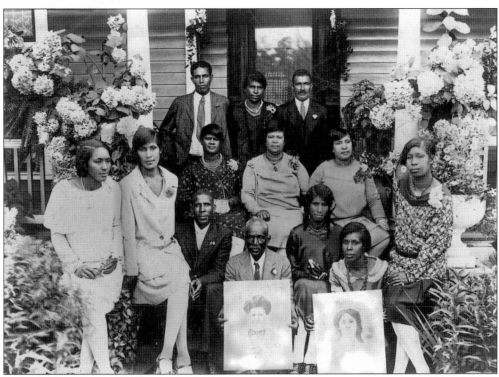

The ladies wear corsages and the men wear boutonnieres as hydrangeas surround this gathering of the Kirkpatrick family, who posed for this photograph on the porch of their home, *c.* 1910. Two family members in the first row hold portraits; at the time, this was a custom to include the deceased. (Courtesy of Robinson-Spangler Carolina Room, Public Library of Charlotte and Mecklenburg County.)

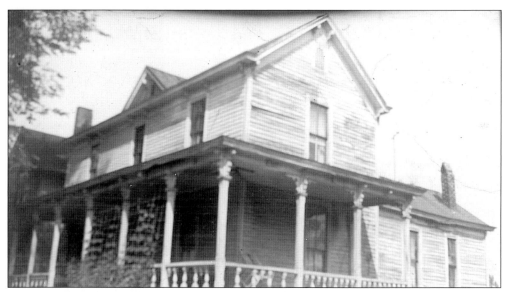

The family of Dr. James A. Pethel lived in this large, early Victorian–style house at 500 North Myers Street in the First Ward neighborhood. Dr. Pethel practiced in Charlotte from 1904 to 1950. Although today First Ward is enjoying a rebirth of sorts with the redevelopment of its homes and businesses, the area is nearly unrecognizable to residents who grew up in the community. (Courtesy of Nancy Pethel.)

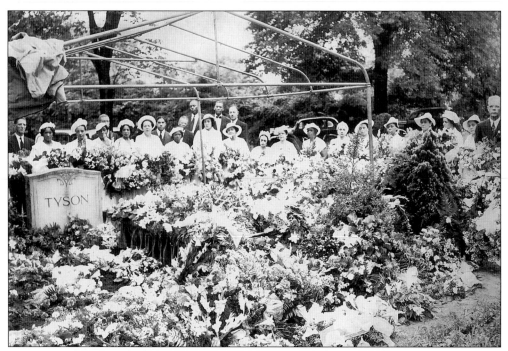

Mourners gather to pay their respects at the funeral of Mrs. E. French Tyson, the wife of Dr. Tyson, a black Charlotte physician who practiced from 1913 to 1950. Residents recall that Grier Funeral Home was in charge of the arrangements. (Courtesy of Constance Sims Grier and Russelle Sims Moore.)

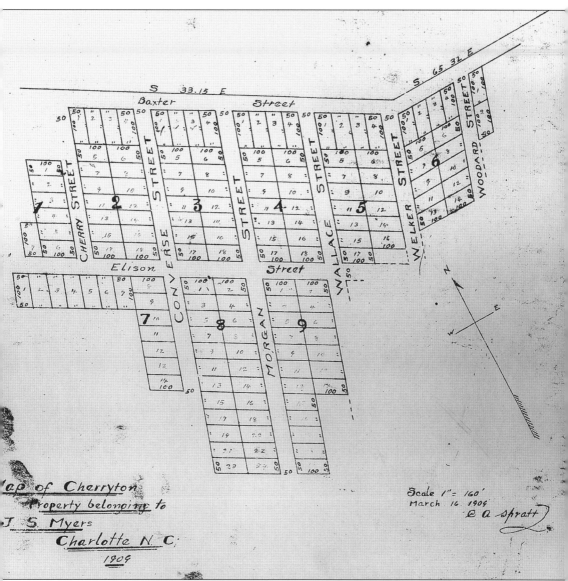

Map of Cherryton
Property belonging to
J. S. Myers
Charlotte N. C.
1909

Scale 1" = 160'
March 16, 1909
E. A. Spratt

A myth persists that the black Cherry neighborhood was developed to provide housing for servants of the white residents who lived in the adjacent and affluent Myers Park. But records show that Myers Park was begun in 1911, more than 10 years after the first plan for Cherry, which was in fact developed to offer black families an opportunity for home ownership away from the crowded areas of downtown. This map shows the street and home lots of Cherry, also known as Cherryton, already platted by March of 1909—two years earlier than the beginning of Myers Park. (Courtesy of Second Ward High School National Alumni Foundation, Inc.)

57

Herbert Hoover was president when this 1929 photograph was taken of Jack Martin on the steps of the Carnegie Library at Johnson C. Smith University. Martin would go on to a career as a successful and beloved athletic coach at West Charlotte High School. (Courtesy of Carolyn M. Wilson.)

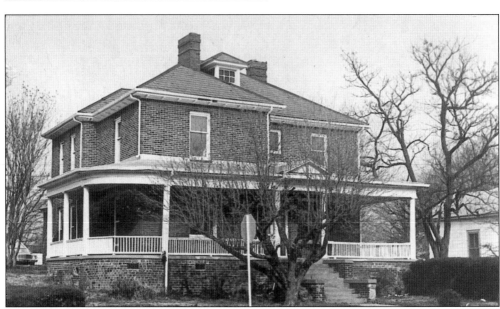

Fortunately, some examples of Charlotte's early architecture have survived, despite occasional intensive efforts to redevelop areas of the city. The grand, two-story George E. Davis house, with its graceful wraparound porch, was named for the first black professor at Biddle University (now Johnson C. Smith University). The house is located at 301 Campus Street near the university campus, and is a locally designated historic landmark. (Courtesy of Second Ward High School National Alumni Foundation, Inc.)

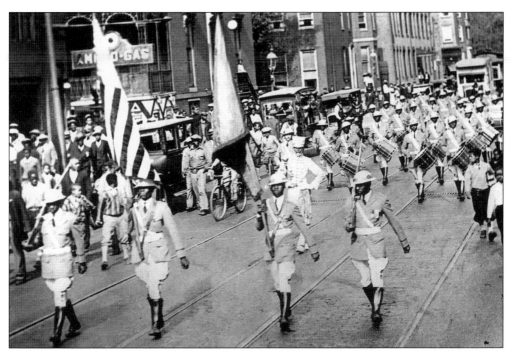

In black communities as well as white, parades celebrate holidays, sports competitions, and victories in war. Here is an undated photograph of the American Legion Drum and Bugle Corps, Colonel Charles Young Post #169. (Courtesy of Annie Mae Dale.)

Many "shot-gun" houses were built in the 1920s. This long, narrow floor plan, consisting of several rooms lined up one behind the other without a hallway, is a style that researchers have traced back through Haiti and western Africa. Homes like these, believed to have been on Third Street, were common in Charlotte's early black neighborhoods. Despite a lack of paved roads and other amenities, many families who grew up in such houses found them adequate, but as the city modernized the disparities became more and more noticeable. By the 1960s, Charlotte's local government had begun a systematic demolition of several neighborhoods such as this one. (Courtesy of Robinson-Spangler Carolina Room, Public Library of Charlotte and Mecklenburg County.)

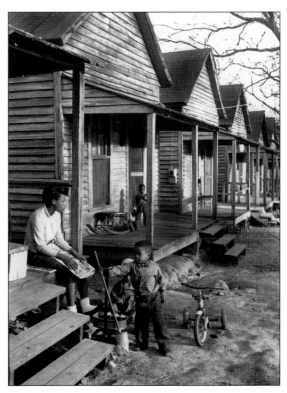

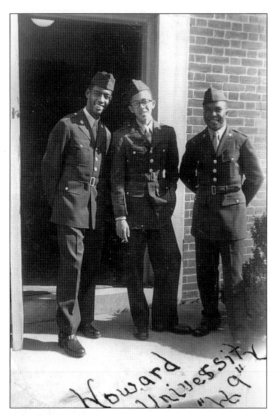

These gentlemen, fresh from a Reserve Officers' Training Course (ROTC), strike a pose in this 1949 snapshot that shows, from left to right, Philadelphian John Mahoney, and Charlotteans Howard Moreland and James Payne. (Courtesy of Second Ward High School National Alumni Foundation, Inc.)

This is Johnson Street in the Greenville neighborhood as it appeared in the late 1960s. City leaders believed the houses had deteriorated beyond saving, and Greenville became another black neighborhood that suffered the loss of its residential core through urban renewal. A number of new houses have been built through the efforts of Habitat for Humanity. (Courtesy of *The Charlotte Observer*.)

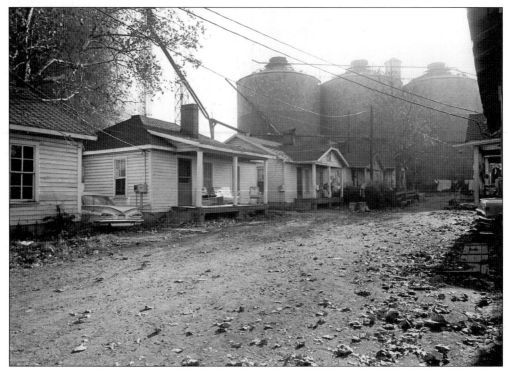

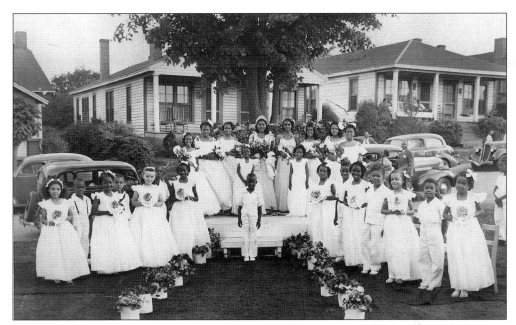

As the focal point of many historically black communities in Charlotte, neighborhood schools hosted holiday events for students. In this charming group portrait believed to be from 1946, the students of Biddleville Elementary School are dressed for the May Day Court. In the background you can see hip-roofed, wood-framed duplexes typically built in Charlotte during the early 20th century. (Courtesy of Carolyn M. Wilson/Alice H. Kibler.)

Many Charlotteans remember the old Eckerd drug store that was located at the corner of Trade and Tryon Streets, until the store was torn down in the city's recent redevelopment. In this early 1940s photograph, Mary Grace Johnson Haynes (Second Ward High School class of 1926) and her daughter, Alice, leave the store with their purchases. (Courtesy of Alice Haynes Kibler.)

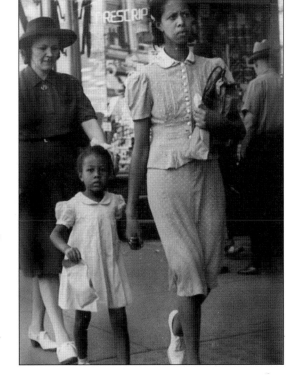

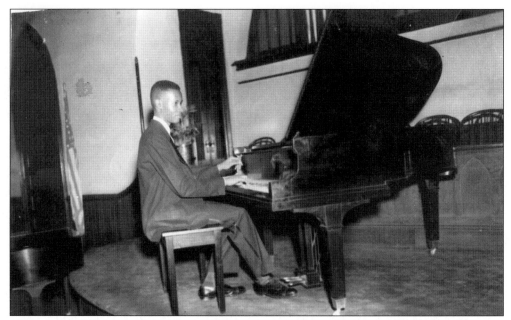

In this undated photo, pianist Dr. Robert Flowe plays from memory without sheet music to prompt him. Flowe, a graduate of Second Ward High School, was the first African American to audition as a student performer with the Charlotte Symphony. He was accepted, but the concert was moved from its regular venue at Ovens Auditorium to the campus of Johnson C. Smith University. (Courtesy of Betty Flowe Pierce.)

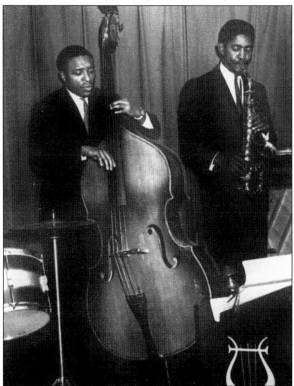

Author LeRoi Jones in his notable book, *Black Music,* calls Charlotte native and accomplished bassist Lewis Worrell "among the best." Worrell, a 1953 Second Ward High School graduate, left his hometown for military service, and was stationed in France, where this 1958 photo with Lucius White of Chicago was taken. Worrell has worked with some of the most innovative talents in jazz, including Sun Ra, Bud Powell, and John Coltrane. (Courtesy of Lewis Worrell.)

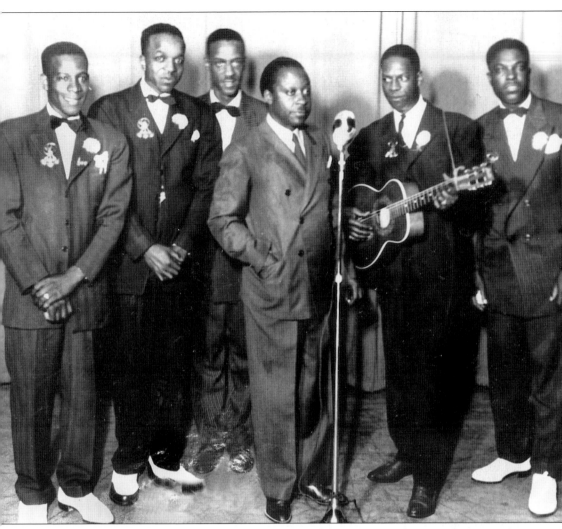

The Golden Bells Quintet was one of the many gospel groups that found an audience in the 1940s through devoted radio listeners. Pictured here, from left to right, are James Maxwell, Lendy Mackie, Louis Samuel, James Lilly, and Boyce Clinton. Manager Ned Davis, who was also a barber and beautician, stands at the microphone. (Courtesy of Kenneth Vinson/Robinson-Spangler Carolina Room, Public Library of Charlotte and Mecklenburg County.)

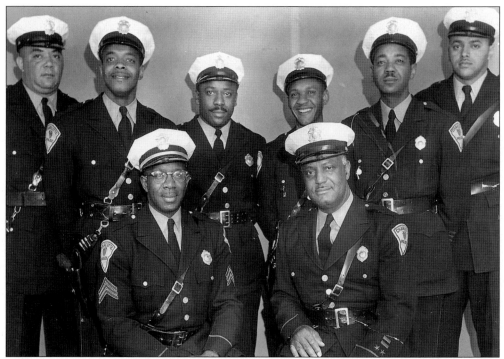

North Carolina's first black police officers were hired in 1941, and they were originally called "special peace officers." They only patrolled the black neighborhoods such as Cherry, Biddleville, and Brooklyn. This later photo shows, from left to right, (standing) Officers Costner, unidentified, George Williamson, William Covington, V. Spencer, and Rudy Torrence; (seated): George Nash and John Lyles. (Courtesy of George and Martha McClinton Williamson.)

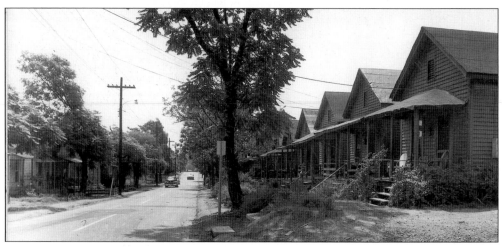

The Second Ward neighborhood, also known as Brooklyn, was home to hundreds of families who lived in the shadow of Charlotte's central business district. The rows of neatly kept "shot-gun" houses, such as these along a typical Brooklyn street, were torn down during the urban renewal movement when city leaders determined the structures were not salvageable. Not only were scores of houses lost, but dozens of black churches, businesses, and civic organizations were displaced along with the area's residents. (Courtesy of Rev. DeGrandval Burke.)

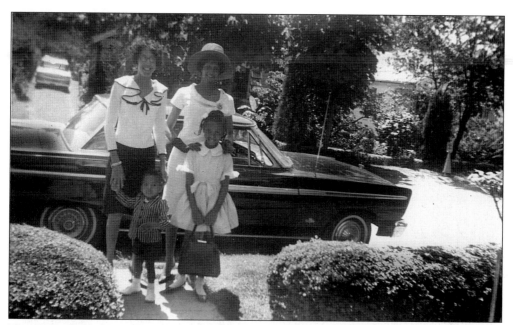

This 1965 photo was taken at 2414 Dundeen Street in the Washington Heights neighborhood. The house still stands today. It escaped the intense urban renewal that claimed the homes of many black families. Members of the Fred and Mildred Johnson family pictured here are Shirley Johnson and Easter Johnson, along with Shirley's children, Benji and Annette. (Courtesy of Rosa "Bill" Johnson Jones.)

Dr. Mildred Baxter Davis was recognized for her exemplary service, and her awards include North Carolina's Order of the Long Leaf Pine, The National Association of Negro Professional Women's Sojourner Truth Award, and the Urban Life Associates Award. She was the first African American to serve on the Board of National Missions of the United Presbyterian Church. (Courtesy of Mary Jones.)

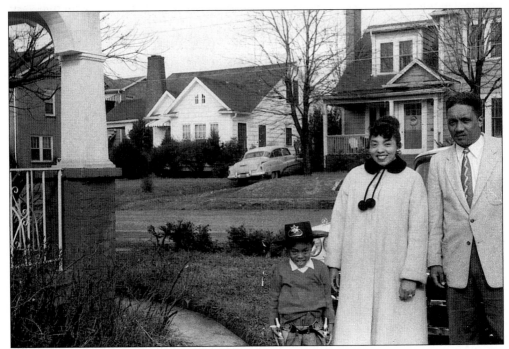

Except for the 1950s car, this Christmas photograph of Don, Elizabeth, and Hodge Johnson Jr. could have been taken just last year. Suburban homes and yards were no longer exclusively the right of white families as blacks claimed a presence in Charlotte's newer neighborhoods beyond the center city. (Courtesy of Margaret "Marty" Johnson Saunders.)

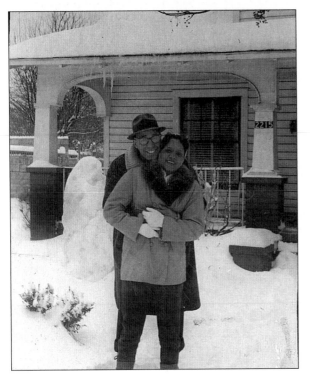

Snowstorms are rare in Charlotte, but young and old alike find it hard to resist the winter wonderland that occasionally results. In this February 1960 photograph, Claude Saunders and Marty Johnson enjoy the snow on Douglas Street near Beatties Ford Road on Charlotte's west side. (Courtesy of Margaret "Marty" Johnson Saunders.)

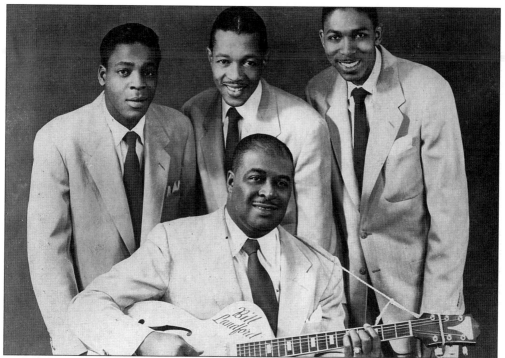

The Bill Landford Quartette was one of the many popular musical groups that became well known throughout Charlotte. Long-time resident Marty Saunders remembers that while in Charlotte, the Quartette lived on Beatties Ford Road at the home of Mrs. Katherine Bowser across from the old city water works. This photo from the 1950s shows Landford with his guitar; behind him are singers Peay, Fludd, and Hayes. Peay would later change his name and become a recording star under his new name, Brook Benton. (Margaret "Marty" Johnson Saunders.)

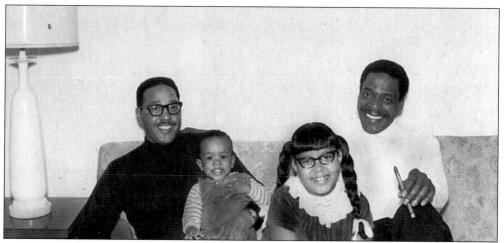

Brook Benton had more than two dozen Top 40 hits from 1959 to 1970, including "Rainy Night in Georgia." This Camden, South Carolina native remained a frequent visitor to Charlotte, where he enjoyed early success as Benjamin Peay, a member of the Bill Landford Quartette. In this 1969 photo, Benton holds a cigar as he visits with, from left to right, Charlotteans Claude, Shawn, and Sharon Saunders. (Courtesy of Margaret "Marty" Johnson Saunders.)

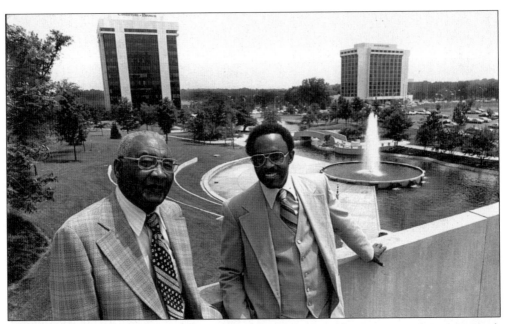

Rev. DeGrandval Burke (left), an historian and longtime faculty member at Johnson C. Smith University, is shown with a companion in this 1975 photo taken on an overlook to Marshall Park. The park was built on land that was once part of Charlotte's Second Ward until the neighborhood was demolished. (Courtesy of Robinson-Spangler Carolina Room, Public Library of Charlotte and Mecklenburg County.)

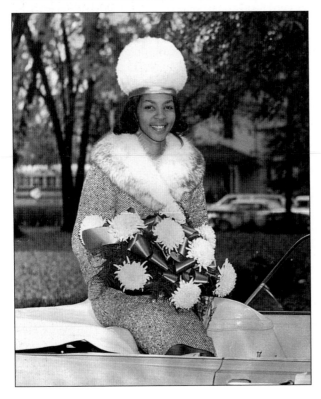

With a fur-trimmed coat and matching hat, Alice Jones Diamond reigned as Miss Johnson C. Smith Alumni in 1965. (Courtesy of Alice Jones Diamond.)

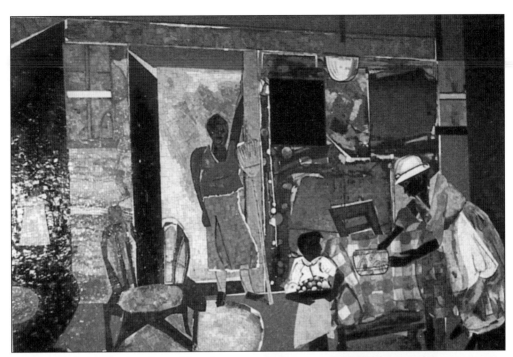

Born in 1911, internationally acclaimed artist and writer Romare Bearden grew up in Mecklenburg County. His colorful and evocative collages are part of some of the most prestigious art collections. The work pictured here, *Before Dawn*, recalls the artist's childhood in the Carolina piedmont. Although the original work is only 12 by 18 inches, it was transformed into a wall-sized mosaic mural more than 9 feet tall and 13 feet wide. The mural is displayed at the Public Library of Charlotte and Mecklenburg County on Tryon Street. Romare Bearden died in 1988. (Courtesy of Robinson-Spangler Carolina Room, Public Library of Charlotte and Mecklenburg County.)

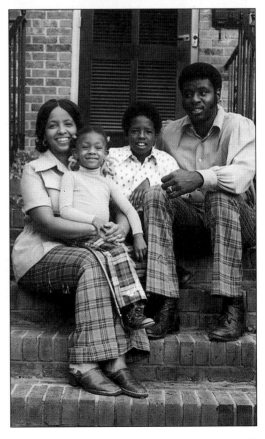

As the civil rights gains of the 1950s and 1960s became almost second nature to Charlotteans, the strict neighborhood segregation began to ease slightly throughout the city. Shown here from left to right is the McClain family, Marilyn, Patrice, Raymond, and Patrick. In January 1970, the McClains became one of the first black families to move into the Hidden Valley community. (Courtesy of Marilyn McClain.)

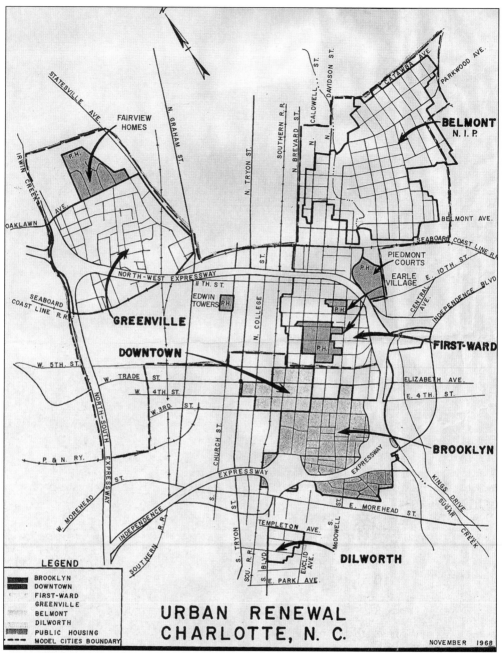

URBAN RENEWAL
CHARLOTTE, N. C.

NOVEMBER 1968

LEGEND

- BROOKLYN
- DOWNTOWN
- FIRST-WARD
- GREENVILLE
- BELMONT
- DILWORTH
- PUBLIC HOUSING
- MODEL CITIES BOUNDARY

This 1968 map shows the urban renewal plans for the African-American neighborhoods in Charlotte that city leaders condemned as blighted. Greenville and First Ward lie on opposite sides of the "North-West Expressway," which would eventually be named for Mayor Stan Brookshire; both neighborhoods are targeted to receive public housing. The "Independence Expressway," which would be named for Mayor John Belk, cuts through the heart of Second Ward, then continues through Third Ward where it meets the "North-South Expressway" (I–77). Little remained of these original neighborhoods, which were once tightly connected, both physically and culturally. (Courtesy of Blondell Carr Sellers.)

Five

FOR THE LOVE OF THE GAME

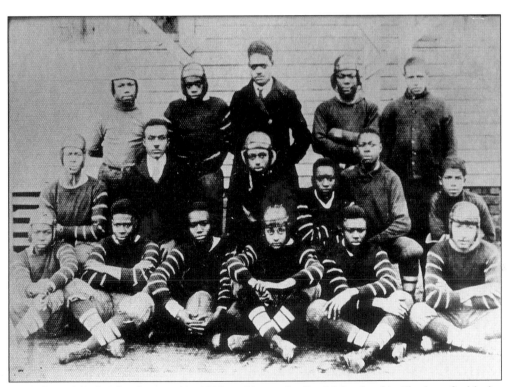

Second Ward High School opened in 1923, and it was the first high school in Charlotte for blacks. This early photo of the Second Ward football team is believed to have been taken during that first 1923–1924 season. (Courtesy of Second Ward High School National Alumni Foundation, Inc.)

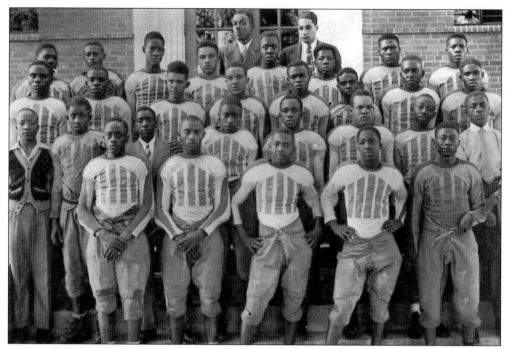

West Charlotte's team was the Lions, and their rivals at Second Ward were the Tigers. The competition was intense and football games between these two teams of "cats" were always an event. Standing at the back of this West Charlotte Lions team photo are coaches Jack Martin and Earl Colston. (Courtesy of James Peeler.)

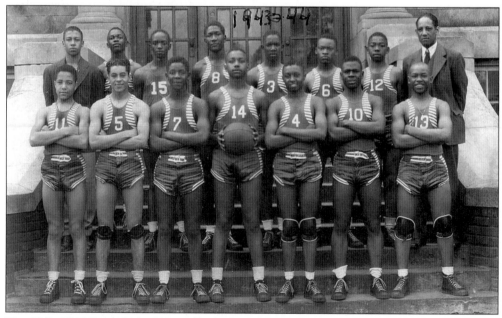

The 1943–1944 Second Ward Tigers had a less than stellar season, ending with a 4-13 record. Coach Kenneth H. Diamond Sr. stands at top right, looking determined to turn it around in the next season. (Courtesy of Second Ward High School National Alumni Foundation, Inc.)

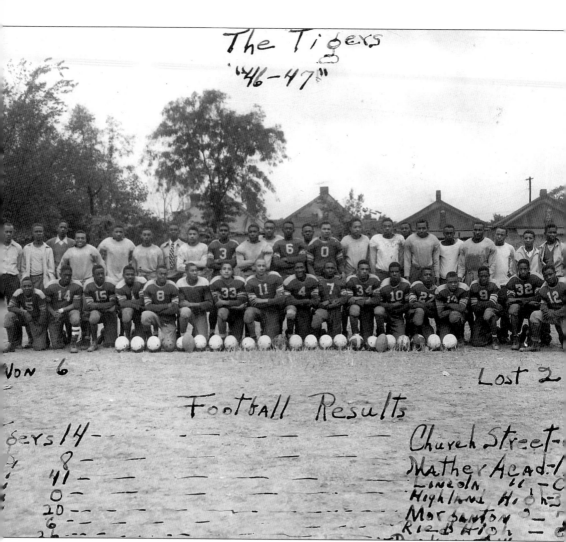

Historians typically warn against writing on old photos, but the information someone wrote on this team picture of the Second Ward Tigers tells more of the story than could be gleaned otherwise. Of the eight games played, four times the Tigers shut out their opponents. But once the Tigers were scoreless, against Highland High, who scored 34 points against them. Their 1946–1947 season ended with a 6-2 record. (Courtesy of T.B. and Geraldine Haynes.)

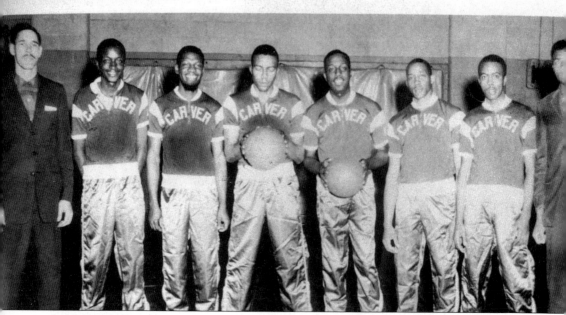

After World War II, Carver College was established to provide higher education to black students in Charlotte. The college was housed at Second Ward High School and the institution eventually became part of Central Piedmont Community College. This team photo shows members of the 1960–1961 Carver College basketball team. Pictured from left to right are Coach Lorenzo George, John "Slim" Williams, James Ross, Thomas Reid, Jack "Chicken" Benson, William Pride, Howard Swift, and James Bray. (Courtesy of Second Ward High School National Alumni Foundation, Inc.)

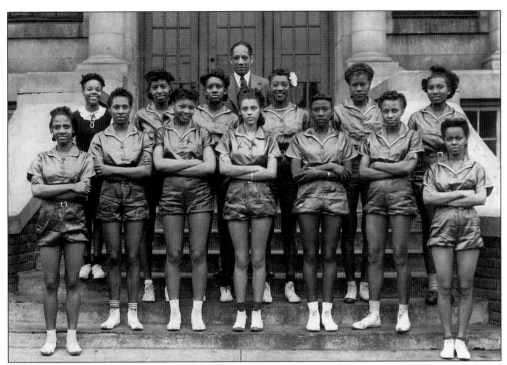

It is not just in recent years that young women have enjoyed sports and competition. These athletes posed for a basketball team picture in 1943–1944. Pictured are, from left to right, (front row) Dora Ramsey, Lucille Boyd, Rosa Ray, Katie Carr, Geneva Thomas, Vancie White, and Norma Yongue; (back row) Flossie Gant, the scorekeeper, Ernestine Manns, Bernice McDowell, Florence ?, Mary Alice Thomas, and Katherine Adkins. Coach Kenneth H. Diamond Sr. stands at the rear. (Courtesy of Vermelle Diamond Ely.)

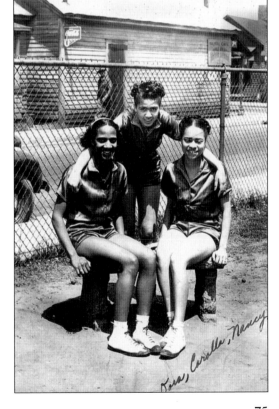

In this snapshot, Dora Ramsey, Corolla Carr, and Nancy Pethel take a breather off the court during a basketball game at Second Ward High School. (Courtesy of T.B. and Geraldine Haynes.)

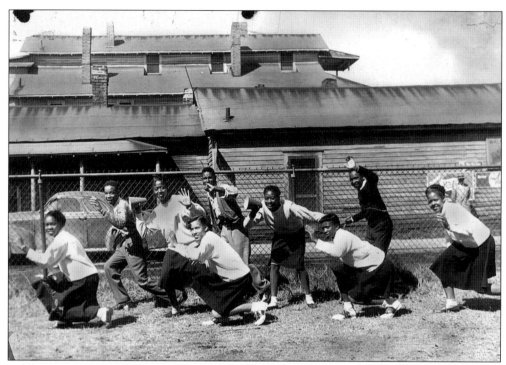

Here's the Second Ward High School cheering squad, ready to show their team spirit. In the front row, from left to right, are Corine Funderburk, Eloise Smith McClain, Sadie Broomfield Pitts, and Clara Davis Vinson. Students in the back row include John Roseboro, Loren Pitts Evans, and Billy Talbert. (Courtesy of Second Ward High School National Alumni Foundation, Inc.)

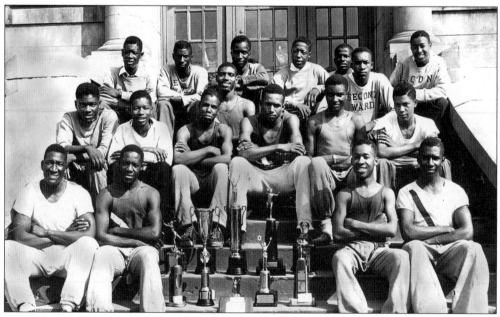

The 1948 North Carolina state champions have good reason to be proud—the track team has at least nine trophies to show for their hard work and determination. (Courtesy of James L. Wright.)

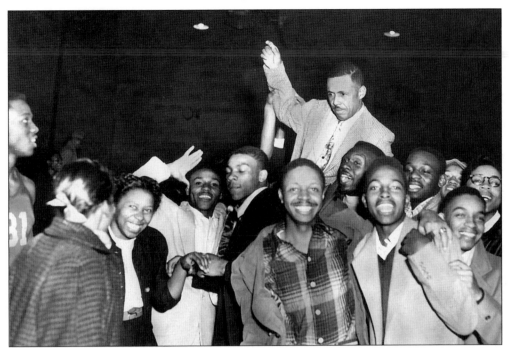

Win or lose, it is the coach who gets the credit or the blame. In this photo from a championship game in the 1950s, West Charlotte High School students celebrate one of their many victories by hoisting coach Jack Martin onto their shoulders. (Courtesy of Carolyn M. Wilson.)

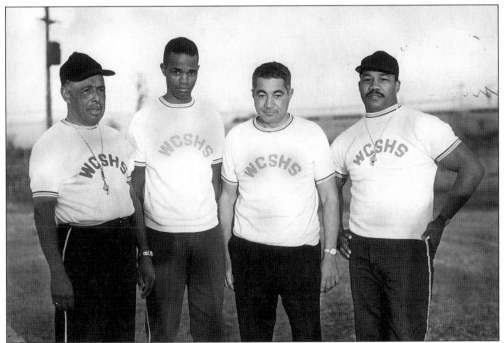

Winning West Charlotte High School coaches Jack Martin, Charles McCullough, Earl Colston, and Frank Roberts pose for this picture in the 1960s. (Courtesy of Carolyn Martin Wilson.)

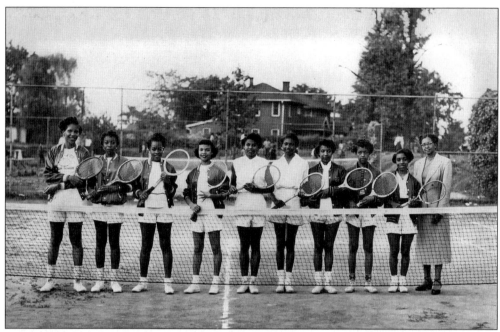

The schools for black students typically had limited athletic facilities. Here is the West Charlotte High School women's tennis team playing on the courts at Johnson C. Smith University. This 1950s photograph shows Minnie Alma Blake with her team. (Courtesy of Geraldine Powe.)

At halftime during the Queen City Classic football games, Miss Queen City Classic would be presented to the crowd. The 1948 queen, Vermelle Diamond, is surrounded by her attendants, Frankie Jackson, Shirley Craine, and Millie Ann Murphy. The gentlemen in the photo are officials from West Charlotte and Second Ward high schools: Mr. Jackson from Carver College, Fred Wiley from Second Ward, J.E. Grigsby from Second Ward, Kenneth H. Diamond Sr. from Second Ward, and Clinton L. Blake from West Charlotte. (Courtesy of Vermelle Diamond Ely.)

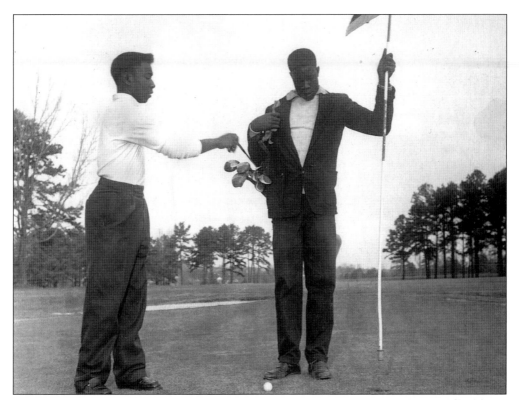

In 1951, blacks who wanted to play golf on Charlotte's whites-only Bonnie Brae municipal golf course were turned away. After a legal battle that lasted six years, a North Carolina court ruled against enforcing the racial restrictions imposed by the donor who gave the land to the city. This 1957 photograph shows golfer James Otis Williams, whom records indicate was the first black to play on the desegregated course. (Courtesy of Robinson-Spangler Carolina Room, Public Library of Charlotte and Mecklenburg County.)

It would be hard to imagine the North Carolina A&T football team without players from Charlotte on the roster. Clockwise from the top are Wiley Harris, John Brooks, Dickie Westmoreland, Robert Faulkner, and George McDowell, receiving instructions from their coach. (Courtesy of Robert Faulkner.)

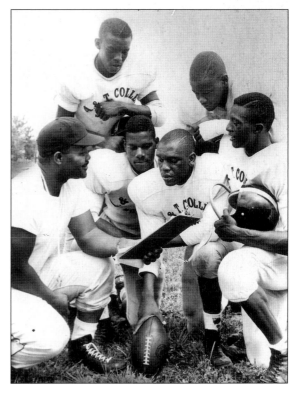

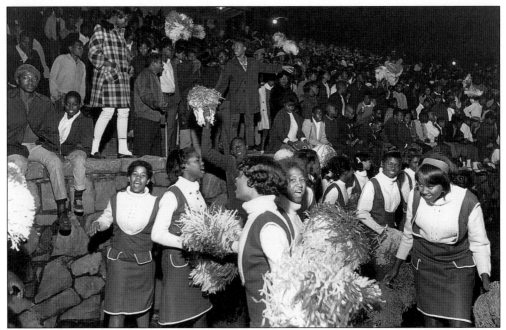

Charlotte's nickname is the Queen City, for a member of European royalty. So the long-running football rivalry between Second Ward and West Charlotte High Schools came to be known as the Queen City Classic. This 1967 photo gives a sense of the size of the crowd that attended the games at Memorial Stadium, and shows the incredible energy of the fans and cheerleaders. There would be only one more Queen City Classic football game after this one, and Second Ward High School would close forever in 1969. (Courtesy of Robinson-Spangler Carolina Room, Public Library of Charlotte and Mecklenburg County.)

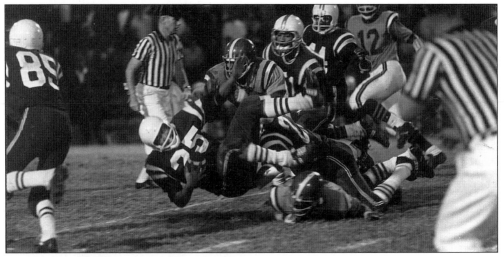

The intense rivalry between the West Charlotte and Second Ward football teams played out each year in the Queen City Classic football games, played at Charlotte's Memorial Stadium. The games began in 1947 and ended in 1968 when the closing of Second Ward High School became imminent. (Courtesy of Robinson-Spangler Carolina Room, Public Library of Charlotte and Mecklenburg County.)

Six
BUSINESS AND
COMMERCE

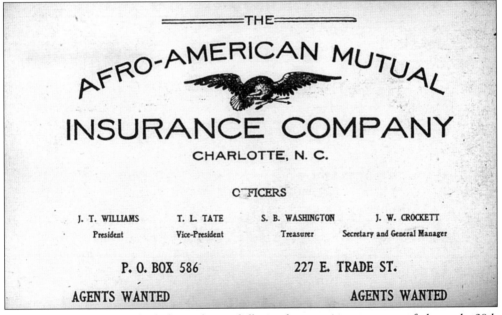

As black families established themselves solidly in the growing economy of the early 20th century, many businesses sought to serve the needs of Charlotte's black middle class. The Afro–American Mutual Insurance Company, headed by members of the prominent Williams, Tate, Washington, and Crockett families, was one such enterprise that proudly proclaimed its managers' names from placards such as the one pictured here. (Courtesy of Second Ward High School National Alumni Foundation, Inc.)

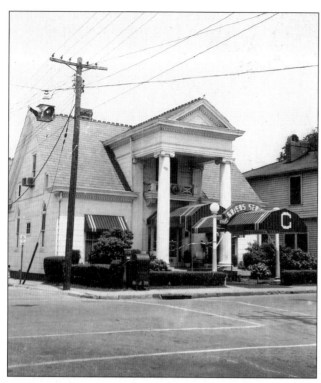

The stately two-story house with the imposing columns at its front was the Grier and Thompson Funeral Home, located at the corner of First and Alexander Streets near Second Ward High School. For decades, the family-owned mortuary served Charlotte's African-American community. (Courtesy of Arthur Eugene Grier.)

This 1937 portrait of the Diamond family was adapted for use as an advertisement that encouraged families to buy insurance. Little Vermelle Diamond looks at a magazine with her mother, Cora; baby Kenneth Diamond Jr. plays at the feet of his father, Kenneth Sr. (Courtesy of Vermelle Diamond Ely.)

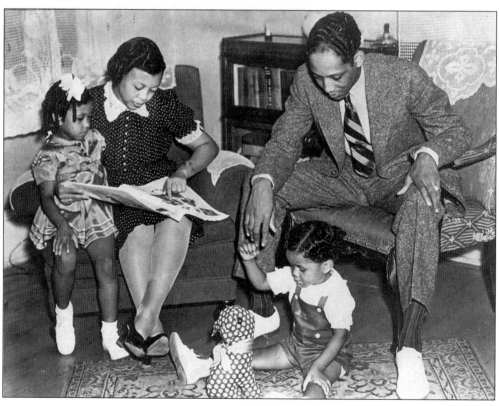

THE MME. C. J. WALKER MANUFACTURING COMPANY,
(INCORPORATED)

640 N. West Street, - - - - **Indianapolis, Ind.**

General Agency Contract

THIS AGREEMENT, made and entered into on the _24_ day of _Aug_
A. D. 1912, by and between Madam. C. J. Walker, president of the
MADAM. C. J. WALKER MANUFACTURING COMPANY, of the City of Indianapo-
lis, State of Indiana, who shall hereinafter be known as Principal,
and _Sarah J. Diamond_ City of _Charlotte_ State of
N. C. who shall hereinafter be known as Agent.

WITNESSETH: That for and in consideration of the mutual agree-
ment of the parties hereto, as hereinafter set forth, IT IS MUTUALLY
AGREED between them as follows:

Said Principal, does hereby agree to teach and instruct said
Agent in the Art of Hair Culture and Hair Growing, giving general and
full instructions as to the proper care of the scalp, use of prepara-
tion and agent's out-fit.

IT IS FURTHER AGREED, that for and in consideration of the
service to be rendered and performed by said Principal, said Agent
hereby agrees to pay to the said Principal the sum of twenty-five
dollars _____ and said Principal does hereby agree that upon re-
ceipt of _____, to supply said Agent with a complete agent's
out-fit, _____ fit to consist of the following articles, to-wit,
One Comb, one-half dozen boxes of Grower, one-half dozen Glossine, one-
half dozen Shampoo.

IT IS FURTHER AGREED, by and between the parties hereto that
said Agent, so created, shall have power to and is hereby authorized to
organize Clubs or Schools to teach and instruct applicants for Sub-
agents, said agent to charge all such applicants the sum of twenty-
five dollars for a complete course of instruction, ten dollars of
which sum is to be retained by said agent, the residue to be sent to
said Principal, said Principal agrees that upon receipt of the above
named sum or residue of fifteen dollars to forward such sub-agent a
complete agent's out-fit, said out-fit to consist of the above named
articles as above set forth, with literature and instructions.

Said above Principal further agrees to give to the agent
sending in the largest number of sub-agents over one hundred (100)
ONE SHARE of the corporate stock of **THE MADAM C. J. WALKER MANU-
FACTURING COMPANY**, Provided, that said largest number over and above
one hundred is sent in within the period of twelve calendar months
after the signing of this agreement.

IN CONSIDERATION of the covenants herein made and agreements
entered into, said agent promises to use no other Hair Preparation
other than that made and prepared by said Principal and company, and
any breach of this **CONTRACT** will render said agent liable under the
Law and will serve as a revocation of said above contract of **GENERAL
AGENCY.**

Before Mary Kay cosmetics parties and Avon Ladies became mainstays of American popular culture, there was Madam C.J. Walker. The African-American hair-care entrepreneur based in Indianapolis gave many women nationwide a start in business, as agents in the Art of Hair Culture and Hair Growing. For $25, each agent would receive an "out-fit" containing Madam Walker's products and authorization to train sub-agents. The woman who recruited the highest number of sub-agents beyond 100 within a year would receive a share of stock in the company. Charlottean Sarah Diamond became a Madam Walker agent on August 24, 1912, and by doing so promised to forego using any hair care products made by any other company! (Courtesy of Second Ward High School National Alumni Foundation, Inc.)

Bobbie Alexander was the proprietress of the Hotel Alexander. Not only was it the first hotel for blacks in Charlotte, for many years it was the only hotel that would accommodate them. (Courtesy of James Peeler.)

Many claimed that in its time, the Hotel Alexander was the largest to accommodate black patrons between Washington and Atlanta. The hotel was located at the corner of McDowell and Ninth Streets. (Courtesy of Rev. DeGrandval Burke.)

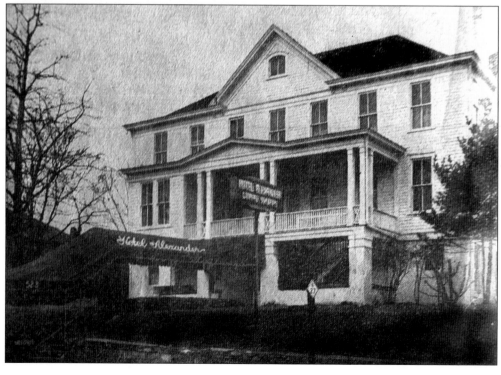

Romeo Alexander was the proprietor of Razades Restaurant, one that was opened so black patrons would have a place of their own to eat and socialize. There were two other enticements to dine at Razades—they were open 24 hours, and the building was air-conditioned. (Courtesy of James Peeler.)

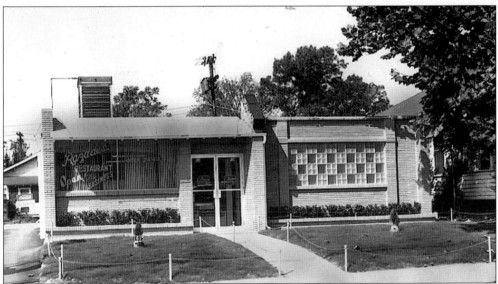

People today may take for granted the ease with which they can walk into a restaurant, sit down, order a meal, and be served. In years past, that was not always possible for African Americans, so black restaurateurs opened their own cafes and grilles to serve patrons who were not permitted to dine elsewhere. Razades Restaurant was one such establishment, located in a modern building on Statesville Avenue, north of downtown Charlotte. (Courtesy of James Peeler.)

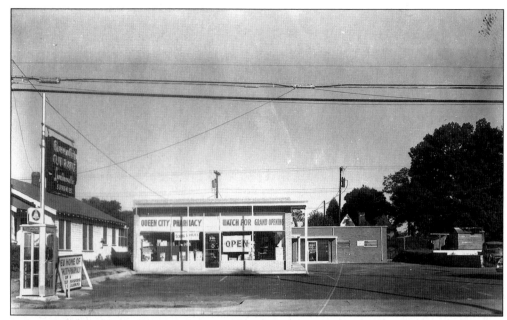

The original Queen City Pharmacy, owned by Elbert Phillips, was located on Second Street in the old Brooklyn neighborhood. Like all the other businesses in that area, it had to move when the neighborhood was razed in the 1960s and 1970s. This photo shows the new Queen City Pharmacy getting ready to open on Beatties Ford Road, next door to the offices of Drs. Wyche and Wilkins. (Courtesy of James Peeler.)

One of nine children, Martha McClinton Williamson always wanted an education so she learned to cut hair, which she then did for more than 50 years. Her first shop was called Martha's Tonsorial Parlor, and it was located on East Second Street in the Brooklyn neighborhood. When the neighborhood was torn down she moved her shop to South Tryon Street. Over the years it's estimated that she gave more than 300,000 haircuts. (Courtesy of Martha McClinton Williamson.)

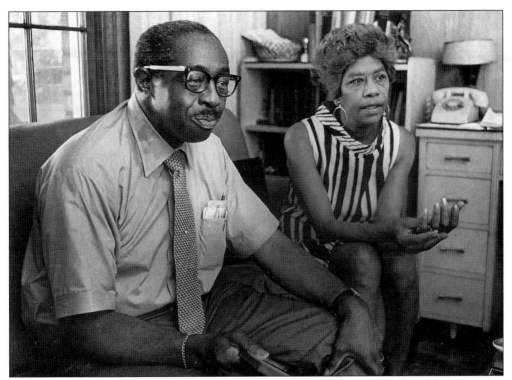

Pictured in this 1970 photograph are Eugene "Genial Gene" Potts and his wife, Ethel. Potts was Charlotte's first black disk jockey, but he also served as principal of Billingsville Elementary School, located in a neighborhood east of downtown Charlotte. (Courtesy of Second Ward High School National Alumni Foundation, Inc.)

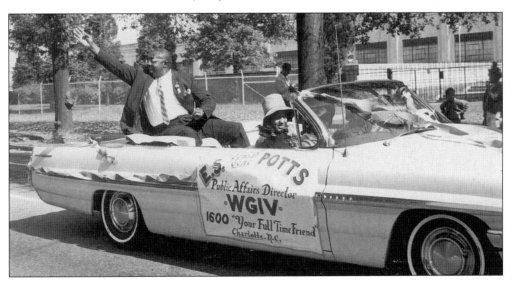

"Genial Gene" Potts waves to the crowd that has gathered to watch the Johnson C. Smith University parade as it makes its way down Beatties Ford Road. Here, the parade passes by the city water works. Potts was a favorite at WGIV radio, which could be heard at 1600 on the AM dial, and billed itself as "Your Full Time Friend." (Courtesy of Margaret "Marty" Johnson Saunders.)

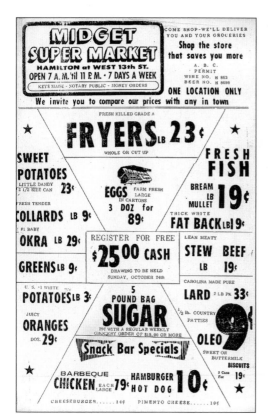

Charlotte native Price Davis recalls that the Midget Super Market was located near the Greenville neighborhood west of downtown. "Shop the store that saves you more" was their motto; they offered to deliver customers and their groceries back home after shopping. Southern tastes have not changed much since this ad, believed to be from the 1930s or 1940s—people still love chicken, greens, sweet potatoes, and biscuits, which were 19 cents. (Courtesy of Second Ward High School National Alumni Foundation, Inc.)

The Coca-Cola logo is the same, but nothing else at the corner of McDowell Street and Independence Boulevard looks the way it did when this photo was taken. Back then, there was both an East and a West Independence Boulevard, and the road ran through downtown Charlotte to connect with Wilkinson Boulevard on the west side and Highway 74 on the east. Today, the John Belk Freeway has replaced the in-town connector route with a loop around the southern edge of the city. (Courtesy of Rev. DeGrandval Burke.)

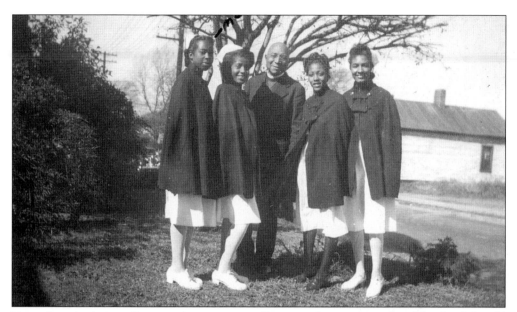

Turned out in their uniforms and capes is a small group of nurses, posed at the side of the old Good Samaritan Hospital, which was located in Third Ward. Dorothy Moore is one of the nurses pictured in this informal snapshot from the 1940s. (Courtesy of Carolyn Moore Lee.)

Good Samaritan Hospital, the area's first hospital for black patients, was built in the late 19th century by the Charlotte Episcopal congregation. The hospital was located in the Third Ward neighborhood, where many black families also resided. Today, Third Ward is unrecognizable. The hospital and surrounding homes are gone, and in their place is Ericsson Stadium, home of the Carolina Panthers. (Courtesy of Blondell Carr Sellers.)

SCHOOL AIM

BEAUTY
A
N
D
SCIENCE

SCHOOL COLORS
SILVER AND MAROON

SCHOOL FLOWER
WHITE ROSE

Bands Beauty College

MRS. A. E. SPEARS President
MR. C. H. BECKWITH Founder

Instructors
MRS. C. F. DAVIS MRS. A. B. McCLELLAND

Music Director
MRS. C. H. BECKWITH

Compliments of

N. C. Mutual Life Insurance Co.

INSURE IN SURE INSURANCE

Mr. A. E. SPEARS, District Manager

The first annual Bands Beauty College commencement exercises were held May 25, 1945, at Biddle Memorial Hall on the campus of Johnson C. Smith University. More than 100 students received diplomas, which was no small task. The North Carolina Board required 1,200 hours of study to become an apprentice cosmetologist. (Courtesy of Janie Deese.)

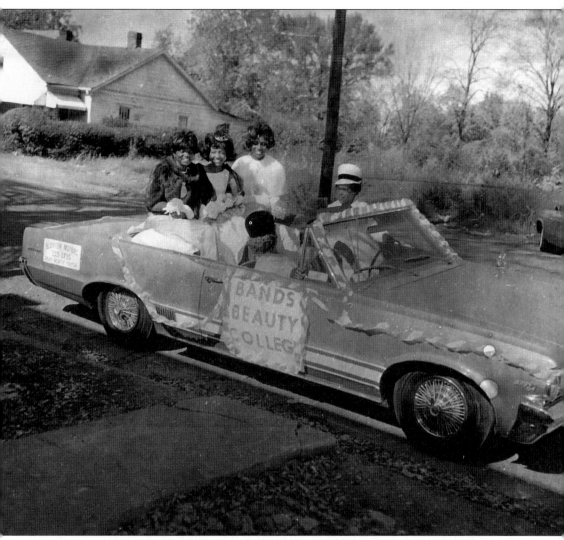

"Opportunity is knocking for you in beauty culture," read an early Bands Beauty College brochure. "A steady income, independence, good pay." Located on Beatties Ford Road, the school offered comprehensive training for aspiring cosmetologists in everything from bacteriology to ethics. Here, Bands beauties, perfectly coiffed, prepare for a ride in a Charlotte parade. (Courtesy of Janie Deese.)

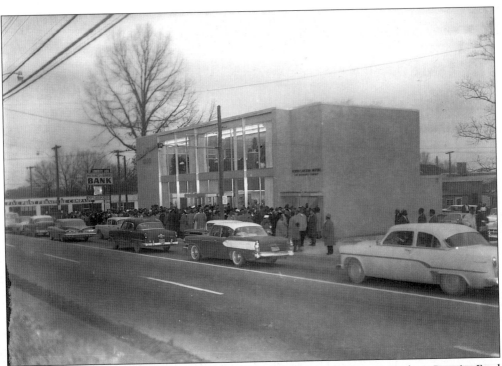

Hundreds turned out for the 1962 grand opening of Mechanics & Farmers Bank on Beatties Ford Road. Begun in Durham, North Carolina, in 1908, the bank would grow to open branches in Raleigh and Winston-Salem as well. A second Charlotte location would later open at Lasalle Street. (Courtesy of James Peeler.)

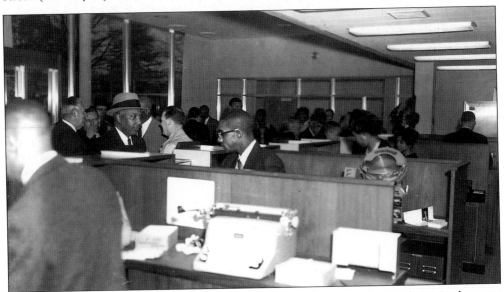

Mechanics & Farmers Bank was the first black–owned bank to open in Charlotte. In the years since, it has won a number of service awards, including the Governor's Business Award. It has also been named Bank of the Year by *Black Enterprise* magazine, and has been listed as one of the 100 Safest Banks by *Money* magazine. (Courtesy of James Peeler.)

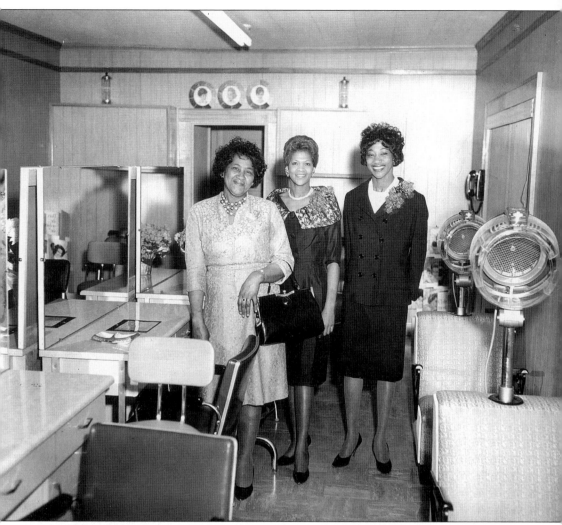

"The welcome mat is out," read the handbill. "Our lovely new House of Charm is open for business . . . every operator is an expert." That was the promise at Tena's House of Charm, shown here. A stylist since the 1950s, Tena Doby started small, with a shop so tiny she once described it to a reporter as a hut. Several moves later, in 1961 she set up shop in this Beatties Ford Road location, where the shop still operates today. Pictured from left to right are her mother Bessie B. Franks, sister Jessie Franks Irby, and Tena Doby. (Courtesy of James Peeler.)

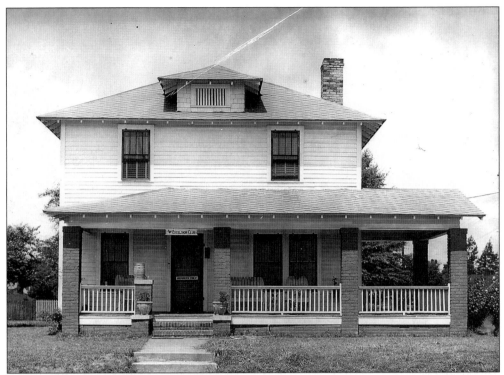

Hardly anyone, even native Charlotteans, would recognize this building. The large, four-square house with off-center porch was built around 1910 on Beatties Ford Road in the Washington Heights neighborhood. It became an important gathering place for black businesspeople, and acquired in 1944 the name it bears today: the Excelsior Club. (Courtesy of Edith Ligon Shearin.)

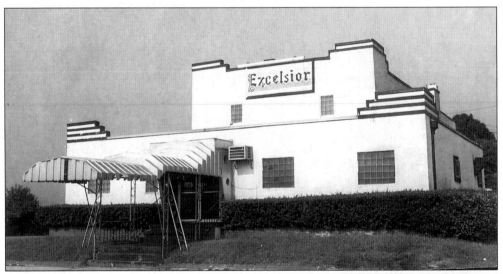

This is the Excelsior Club as it appears today, nearly 50 years after its 1952 transformation from a two-story, wood-framed house into the Art Moderne eye-catcher pictured here. Local officials would later recognize club founder James Robert "Jimmie" McKee for his civic contributions by proclaiming November 16, 1984 as "Jimmie McKee Day." (Courtesy of Edith Ligon Shearin.)

Seven
CIVIC AND SOCIAL LIFE

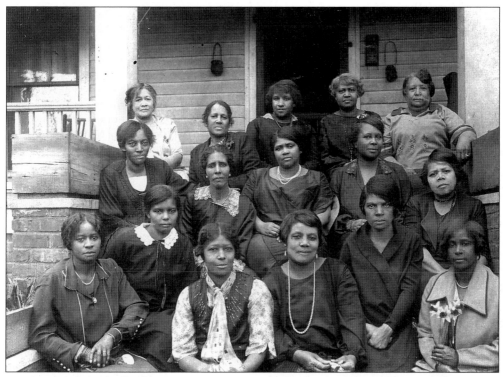

Members of the Southside Art and Literary Circle posed for this *c.* 1917 portrait on the front steps of the Zechariah Alexander home, which was located at 415 East Stonewall Street. Mrs. Louise Alexander is second from the left on the front row. (Courtesy of Margaret A. Alexander.)

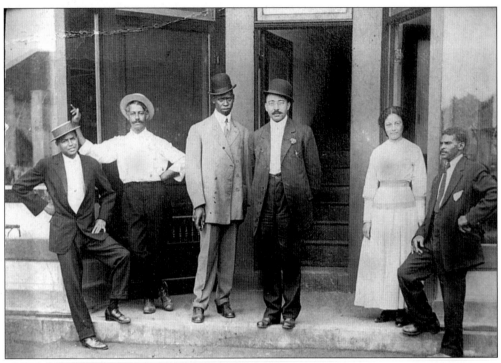

This photograph, believed to date from sometime between 1907 and 1910, is an informal portrait made at the front of the Sanders Drug Store. A notation on the back of the photograph lists the group as members of the Friday Evening Social Club. (Courtesy of Second Ward High School National Alumni Foundation, Inc.)

At the corner of First and Myers Streets in the old Second Ward neighborhood, friends Joe Grier and Floyd Wallace are dressed in style as they smile for the camera in this rare, early photograph. (Courtesy of Mildred and Joe Grier.)

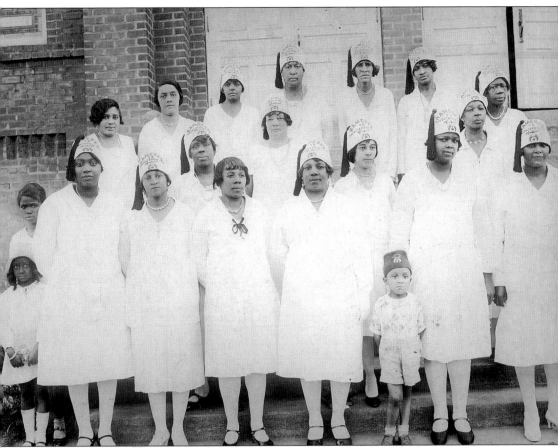

Men's masonic organizations have origins that date back many generations. Popular, too, are sister organizations for the wives and daughters of the members. This *c.* 1930 photograph shows the Rameses Court of the Daughters of Isis, Chapter #78, outfitted in their customary white dresses. (Courtesy of Vermelle Diamond Ely.)

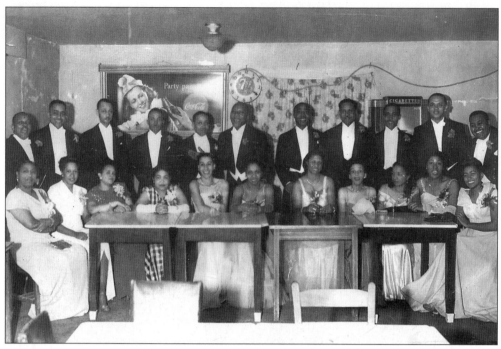

1925 1939

The

Club

Charlotte, North Carolina

Their emblem was a black cat silhouette, and members of this social club called themselves the Black Cats. While portraits often show the club members celebrating with their wives in formal dress, the Black Cats and other social clubs also frequently undertook charitable and civic activities. (Courtesy of Vermelle Diamond Ely.)

This ribbon-tied booklet from 1939 contained an invitation that welcomed members to "Frolic Christmas Morn at the Athenaeum Ballroom with the Black Cats to the music of the Dixie Serenaders." There was even a special blank page inside to collect "memoirs and autographs" of the event. (Courtesy of Vermelle Diamond Ely.)

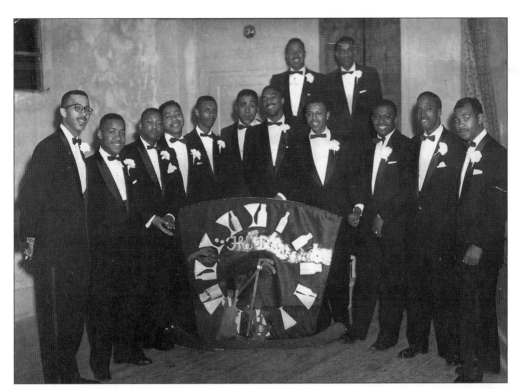

This portrait of the Socialistic Dukes club included members Howard Moreland, Doug Spears, James McGill, Lee Ervin, Danny Freeman, Willie Lawing, Leroy Polk, Clarence Rickett, Charles Porter, Wade Mosley, Joseph Harper, and Hazel "Runt" Ellis. (Courtesy of Rufus "Doug" Spears.)

Their pep song was sung to the tune of "Down by the Old Mill Stream," and the lyrics were: "Clean fun, clean sports our aim/Socialistic Dukes our name/A higher goal and fame/Is just what we proclaim/In schools and communities/That's where our work will be/Hold high the Dukes, Socialistic Dukes/Socialistic Dukes are we." The club dated back to the 1940s, and this four–page booklet contained a 1949 invitation to the club's semi-formal anniversary ball, which was held on December 26 each year. (Courtesy of Vermelle Diamond Ely.)

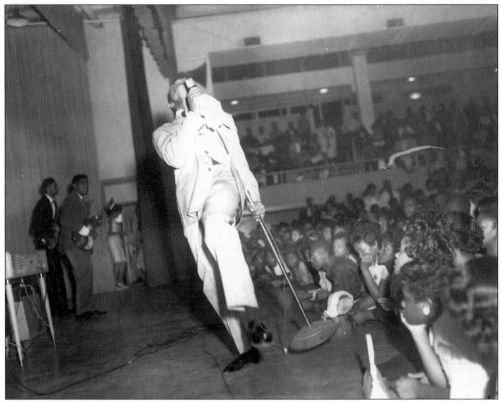

The crowd packed the house and pressed up to the stage at the Hi-Fi Club to hear performer Ernie K-Doe sing the hit song "Sittin' on My Ya-ya, Waiting for My La-La." (Courtesy of James Peeler.)

Let's celebrate! Clubs such as the Black Cats and Socialistic Dukes often hosted formal events as part of their holiday activities. (Courtesy of Second Ward High School National Alumni Foundation, Inc.)

There was no lack of social and civic club activity in Charlotte's African-American community. This group portrait from the 1950s shows members of the Charlotte chapter of Links, Inc. From left to right are (front row) Aurelia Henderson, Maria Wynn, Nancy Williams, Ruth Washington, Catherine Hawkins, Jackie Hairston, Carolyn Graham, and Julia Bolding; (back row) Dr. Roy Wynn, Cora Booton, Dr. A.J. Williams, Joseph Belton, John Hairston, Walter Washington, Dr. Robert Greene, Gladys Green, Allegra Westbrooks, Dr. Reginald Hawkins, Lawyer Bolding, Dr. Drayton Graham, Fannie Porter Dobson, Edna Morris, and Thelma Byers. (Courtesy of James Peeler.)

Kelly Alexander recognizes Mrs. U.S. Brooks, Charlotte's NAACP chapter president at the time. This photograph was taken in Charlotte at the Park Center, now known as the Grady Cole Center. (Courtesy of James Peeler.)

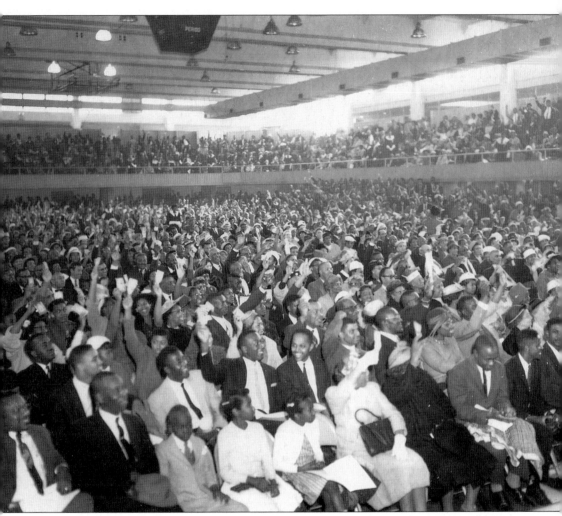

They packed the house, and enthusiastic attendees are seen waving their arms to show their support for the speakers at this NAACP meeting that was held at Charlotte's Park Center. (Courtesy of James Peeler.)

Those who believed that civic progress and charitable efforts belonged exclusively to white society were mistaken. Many middle class black citizens participated in projects that benefited the community. One such group was the Charlotte Medical Auxiliary, pictured here. Joretha R. Isler is seated front row, center. (Courtesy of Grace Hoey Drain.)

Here are members of the Charming Ones Social Club. The hostess is Dorothy Weddington Hayes, and the inscription on the back of this photo indicates it was taken "at the home of Uncle Willie Davis" on Baldwin Avenue in the Cherry neighborhood. (Courtesy of Dorothy and Walter Hayes.)

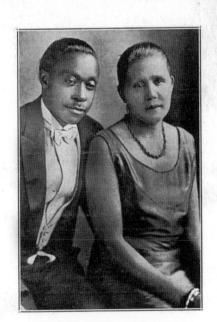

Nathaniel Delano (Ned) Davis
Celebrates his 36th Birthday anniversary
He is shown above with his devoted wife
Mrs Mildred L. Davis

It was quite stylish to print up announcement cards for special occasions such as birthdays and anniversaries, but Nathaniel Delano "Ned" Davis was more stylish than most. He was a beautician, barber, and entrepreneur, among his many talents. This is a portrait of Ned Davis and his wife, Mildred L. Davis. (Courtesy of Obie Blackwell.)

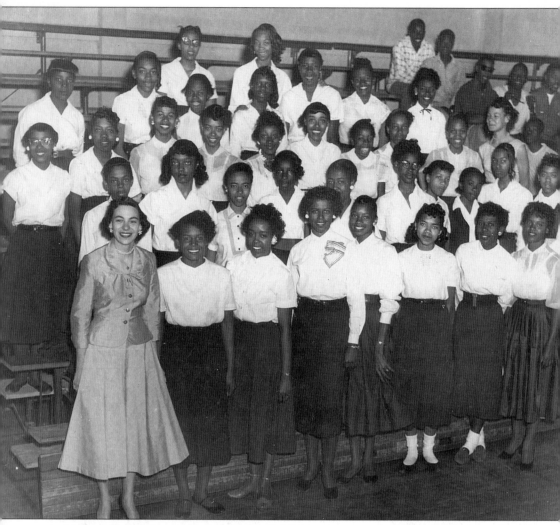

Activities at the YMCA were not just for small children; teenagers had their own group, called the Y-Teens. But since recreation centers, like schools and parks, were segregated before integration efforts took hold, black neighborhoods had their own facilities. This Charlotte group posed for a portrait on Y-Teen Day in April 1955. (Courtesy of T.B. and Geraldine Haynes.)

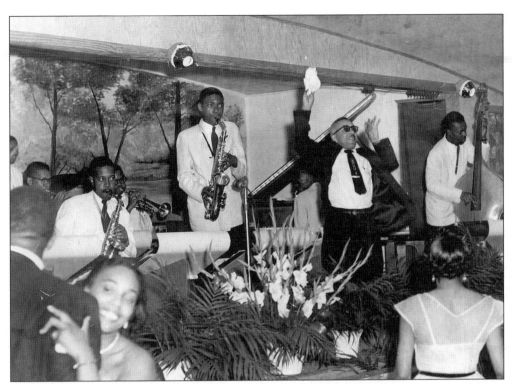

Diminutive but energetic bandleader Raymond "Flat Tire" Mason fronted an impressive line-up of musicians in these photos taken at the Hi-Fi Club on Estelle Street in the early 1950s. Musicians in the group include Dave Cook, Freddie Garvin, Daniel Owens, Clifford Tinsley, Morris Donald, William Etheridge, Maurice Robinson, Johnny Holloway, and Raleigh Wheeler. (Courtesy of Morris Donald/Edith Ligon Shearin.)

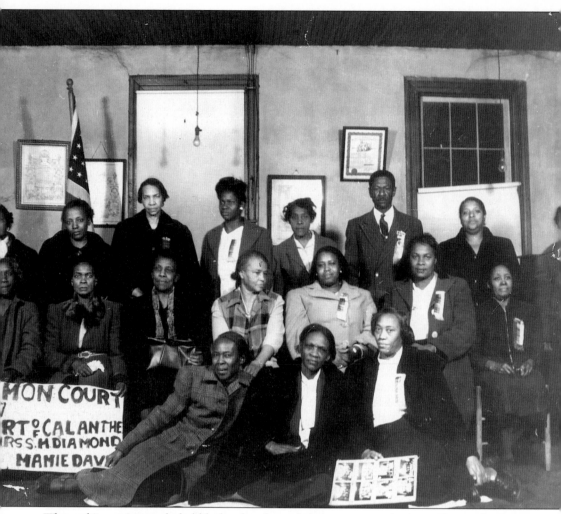

When white society excluded blacks, they formed their own organizations. Here is the Damon Court #497, Court of Calanthe, another of Charlotte's African-American social clubs. (Courtesy of Rev. DeGrandval Burke)

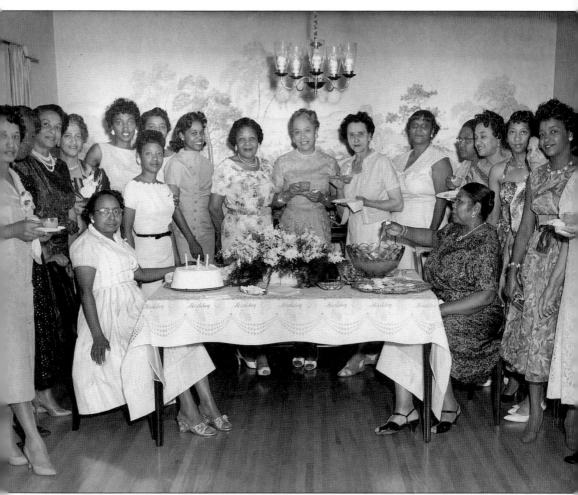

In summer dresses, pearls, and high heels, these ladies—probably elementary teachers—held a birthday celebration with cake and punch. (Courtesy of Second Ward High School National Alumni Foundation, Inc.)

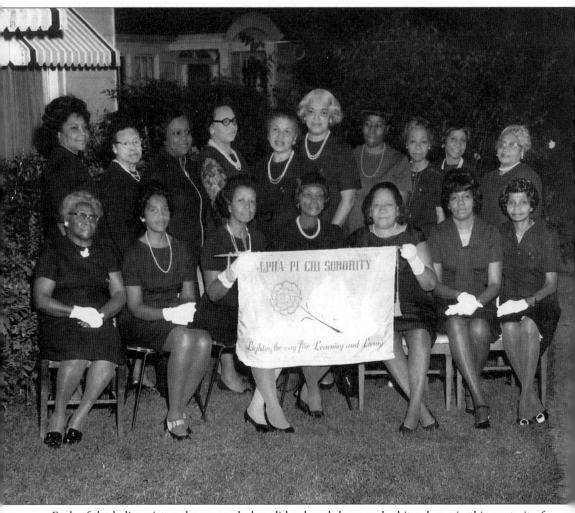

Each of the ladies pictured wears a dark, solid-colored dress and white gloves in this portrait of the Alpha Pi Chi service sorority. The club's motto was "Lighting the way for Learning and Living." (Courtesy of Margaret "Marty" Johnson Saunders.)

Lovely Shirley Ashcroft, May Queen of 1955, smiles for the camera as Second Ward High School principal J.E. Grigsby looks on. (Courtesy of Geri Haynes.)

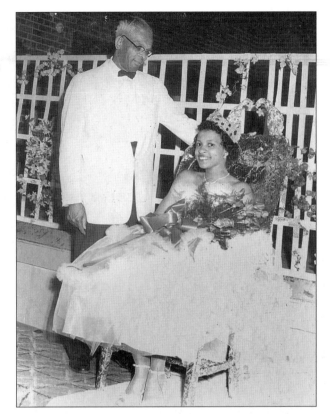

Twelve fashionable young ladies and their escorts posed for this cotillion photograph in the 1940s at Second Ward High School. Strict standards of dress were observed for the occasion, right down to the above-the-elbow-length gloves. (Courtesy of Vermelle Diamond Ely.)

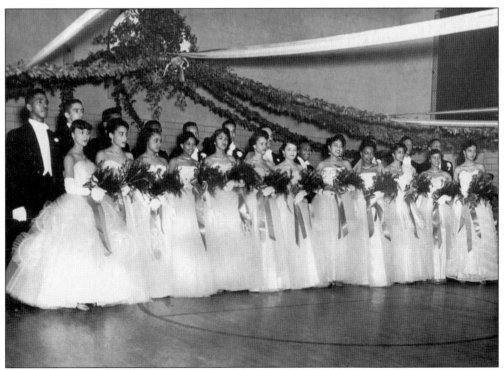

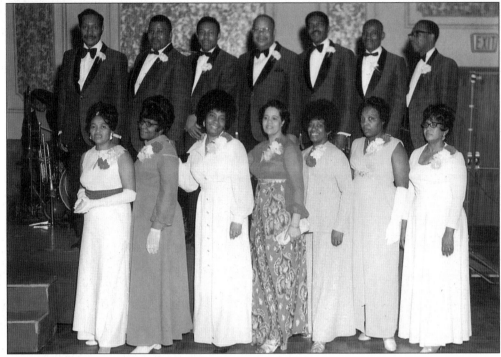

The Industrial Men's Club was founded in 1944. Pictured here at a formal event that was held at the Hotel Charlotte are the following married couples, from left to right: Edward Hogue and Alma Hogue; Samuel Spears and Neomia Spears; James Culberth and Catherine Culberth; John W. Lester Sr. and Helena Lester; James "Slack" Steele and Barbara C. Steele; Clayton Pride Sr. and Louise Pride; and Neal Alexander and Zora Alexander. (Courtesy of James "Slack" Steele.)

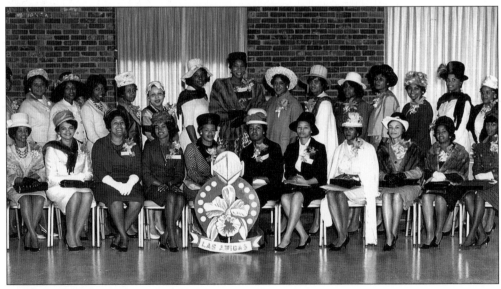

A national women's service organization dedicated to "the betterment of all communities," Las Amigas Incorporated held its first conclave in Charlotte in April 1963. (Courtesy of Dora Mason/Second Ward High School National Alumni Foundation, Inc.)

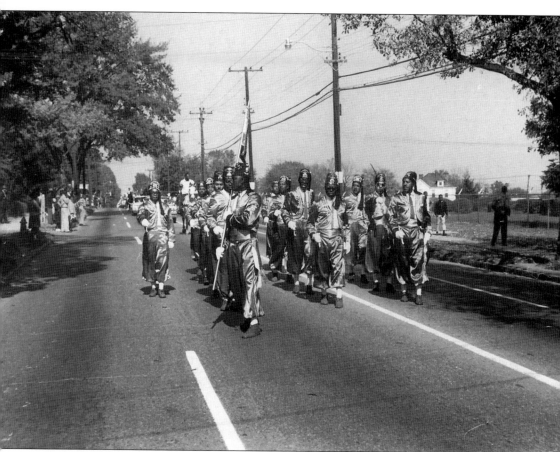

The Brookshire Freeway cuts through what used to be a residential section of West Charlotte. This snapshot was taken before the highway project, and shows the Shriners in Johnson C. Smith University's homecoming parade as the group marches down Beatties Ford Road past the city water works. (Courtesy of Margaret "Marty" Johnson Saunders.)

This well-dressed group of ladies is the National Council of Negro Women, Charlotte Section, at their Founder's Day Celebration at First Baptist Church West. (Courtesy of Marilyn McClain.)

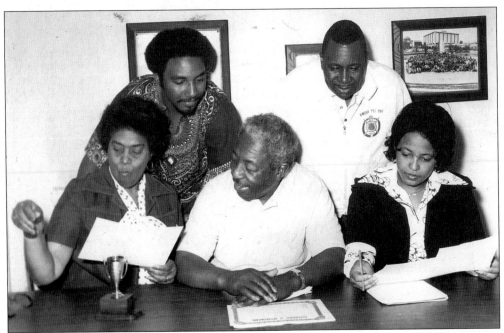

The Pan Hellenic Council Program Committee gathered in a planning session to prepare for their national convention to be held in Charlotte. Members of the committee, from left to right, are (seated) Esther Hargrave, Zoel Hargrave, and Marilyn C. McClain; (standing) Ronald Swann and R. Pete Reeder. (Courtesy of Marilyn McClain.)

Eight
TURNING POINTS

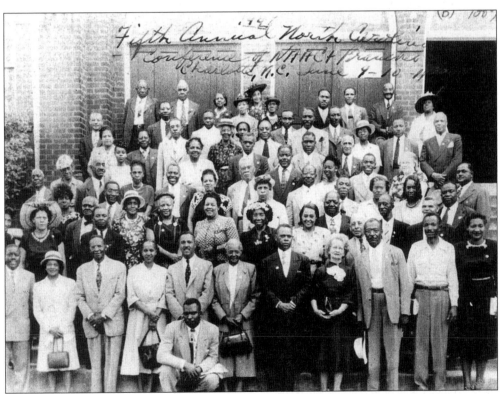

In 1948, the North Carolina State Conference of the branches of the NAACP met in Charlotte, and elected prominent, local funeral director and civil rights activist Kelly M. Alexander Sr., as state conference president. This photo, taken on the front steps of Charlotte's Ebenezer Baptist Church on East Second Street, shows Alexander kneeling front of a gathering of the conference attendees. Alexander would go on to serve as the National Board Chairman of the NAACP. (Courtesy of Margaret Alexander.)

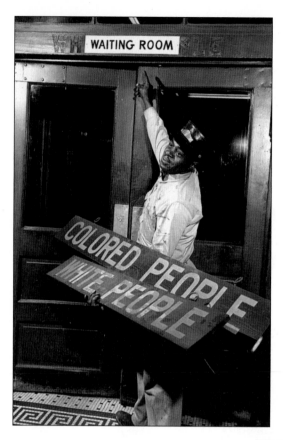

Like many Southern cities, change came slowly to Charlotte. Although the U.S. Supreme Court had ruled in 1947 that segregation in interstate travel was unconstitutional, many Southern train and bus stations were still segregated a decade later. In January of 1956, redcap Wilbert Martin, father of Mary Martin Jones, oversaw the removal of the signs designating separate waiting rooms at Charlotte's Southern Railway station. (Courtesy of Robinson-Spangler Carolina Room, Public Library of Charlotte and Mecklenburg County.)

Under the direction of Executive Secretary Kelly Alexander Sr., Charlotte boasted a very active chapter of the NAACP. One local chapter program brought nationally recognized civil rights leaders, such as New York Congressman Adam Clayton Powell Jr., to Charlotte. More than two dozen local businesses placed ads in the event program for Powell's 1946 visit. (Courtesy of Blondell Carr Sellers.)

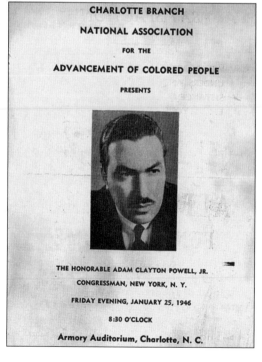

CHARLOTTE BRANCH

NATIONAL ASSOCIATION

FOR THE

ADVANCEMENT OF COLORED PEOPLE

PRESENTS

THE HONORABLE ADAM CLAYTON POWELL, JR.

CONGRESSMAN, NEW YORK, N. Y.

FRIDAY EVENING, JANUARY 25, 1946

8:30 O'CLOCK

Armory Auditorium, Charlotte, N. C.

On September 4, 1957, the same morning that three other African-American students set out to become the first blacks to attend all-white Charlotte public schools, Delois Huntley smiled bravely from the porch of her home in this photo attributed to noted African-American photographer James Peeler. At Alexander Graham Junior High School, she was spared the taunts and attacks that befell others, but her experience was difficult nonetheless. (Courtesy of Robinson-Spangler Carolina Room, Public Library of Charlotte and Mecklenburg County.)

The strain of her ordeal is evident in this photo of Delois Huntley, the first black student to break the color barrier at previously all-white Alexander Graham Junior High School. Although photos taken earlier in the day show a hopeful young woman setting out for school, this photo captured Delois sitting alone at a corner desk, very much aware that she is being ignored by her classmates. (Courtesy of Robinson-Spangler Carolina Room, Public Library of Charlotte and Mecklenburg County.)

117

Of the four desegregation pioneers who first integrated Charlotte's previously all-white schools, two were from the same family. This photo of Gus and Girvaud Roberts leaving for school early the morning of September 4, 1957 is thought to have been taken by noted African-American photographer James Peeler. (Courtesy of Robinson-Spangler Carolina Room, Public Library of Charlotte and Mecklenburg County.)

Gus Roberts, Girvaud's older brother, encountered resistance when he entered Central High School but the calm leadership of school administrators prevented trouble. Of the four black students who entered all-white Charlotte schools on the first day of integration, only Gus remained to graduate from his school. He went on to work in public education, and became superintendent of schools in Darlington, South Carolina. (Courtesy of Robinson-Spangler Carolina Room, Public Library of Charlotte and Mecklenburg County.)

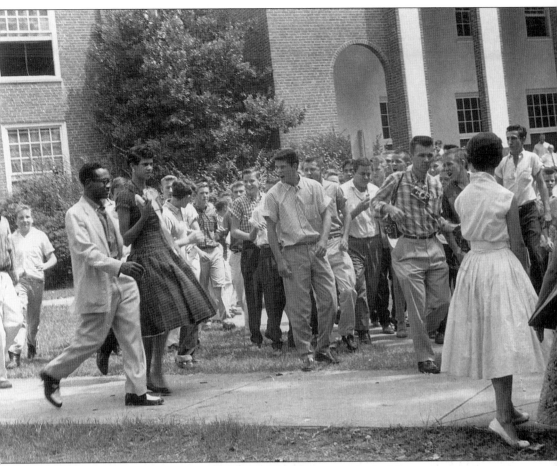

Fifteen-year-old Dorothy Counts walked through an angry crowd of white students to become the first African American to attend Harding High School. As she entered school that first day in 1957, she endured taunting, racial epithets, and being spat on. In this photo, Dr. Reginald Hawkins escorts her as she leaves school. As the week wore on, the pressure grew. Dorothy's locker was ransacked, students threw trash at her, and teachers ignored her. Despite the efforts of some sympathetic classmates, after four days of increasing hostility, Dorothy's parents withdrew her from Harding and sent her to live with relatives and attend school in Pennsylvania. Today, Dorothy Counts Scoggins makes her home in Charlotte. (Courtesy of Robinson-Spangler Carolina Room, Public Library of Charlotte and Mecklenburg County.)

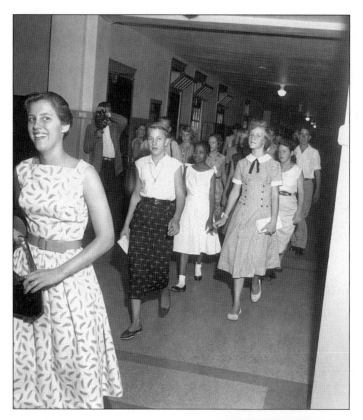

Girvaud Roberts, the first African American to attend Piedmont Junior High in Charlotte, peacefully joined the student body on September 4, 1957, amid concerns that protests could turn violent. Fortunately, they did not. (Courtesy of Robinson-Spangler Carolina Room, Public Library of Charlotte and Mecklenburg County.)

Before the sit-in movement of the 1960s led to desegregated lunch counters in the South, often blacks could only stand and order food to take out. One early exception was McClellan's on North Tryon Street, which in the 1940s installed a separate lunch counter where blacks were allowed to sit—in the store's basement. Mildred Feemster became the first black manager there, serving barbecue, banana splits, and strawberry shortcakes. "People were three and four deep every Saturday," she recalls. (Courtesy of Rev. Mildred Feemster Caldwell.)

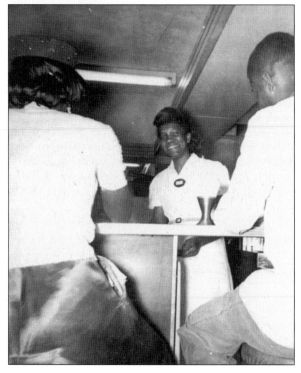

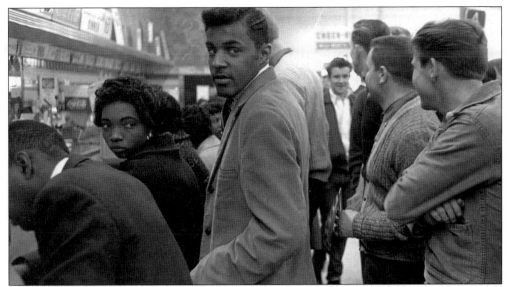

To protest segregation, on February 1, 1960, black students took seats at the whites-only lunch counter at Woolworth's in Greensboro, North Carolina. Charles Jones, a seminary student at Johnson C. Smith University, heard the news report and within a week had helped organize his fellow students into protests at Kress, Woolworth's, and other lunch counters such as this one in Charlotte. Although peaceful, the sit-ins were part of a chain reaction of civil rights protests, some of which turned violent, throughout the South. (Courtesy of Robinson-Spangler Carolina Room, Public Library of Charlotte and Mecklenburg County.)

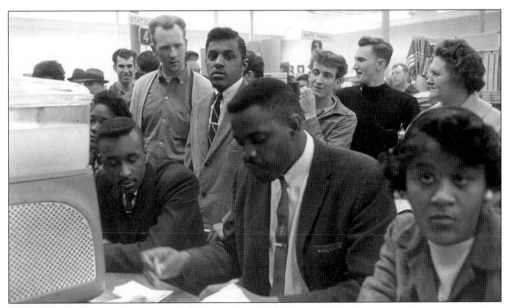

As white patrons stood to vacate their seats, black students took their places at lunch counters in Charlotte as the sit-in movement continued. Organizer Charles Jones would later become one of the Freedom Riders who put their lives at risk to integrate buses in the South. Slowly, Southern cities would become more and more integrated, due to the work of dedicated activists. (Courtesy of Robinson-Spangler Carolina Room, Public Library of Charlotte and Mecklenburg County.)

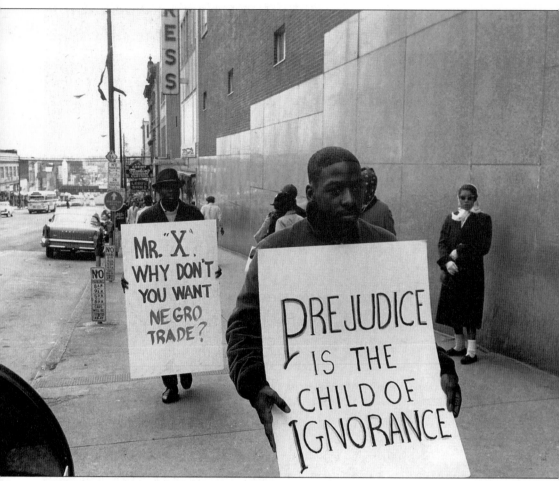

The year 1960 was a pivotal one in the struggle for civil rights in the South. These Charlotteans are shown marching outside the Kress store in downtown in February of that year, the same month that the sit-in movement began in Greensboro, North Carolina. The examples of non-violent direct action would lead two months later to the founding of the Student Non-violent Coordinating Committee (SNCC). (Courtesy of Robinson-Spangler Carolina Room, Public Library of Charlotte and Mecklenburg County.)

In 1964, Dr. Martin Luther King Jr., was the featured speaker at a combined graduation ceremony for six black Mecklenburg County high schools. The ceremony was held at the old Charlotte Coliseum. Within the year, Dr. King would be awarded the Nobel Peace Prize for his leadership during the civil rights movement. (Courtesy of Gerson Stroud.)

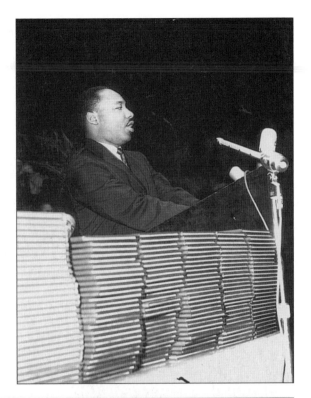

Thirty-six years later, retired York Road High School principal Gerson Stroud still remembers the names of his fellow principals who attended the graduation ceremony at which Dr. King spoke. In addition to Stroud, pictured are the following: L.E. Poe, Isaac Graham, Spencer E. Durante, Joseph Belton, and C.L. Blake. (Courtesy of Gerson Stroud.)

In September 1966, Dr. Martin Luther King Jr. returned to Charlotte to address the Catawba Synod Commission on Religion and Race, part of a national effort by the United Presbyterian Church, U.S.A., to promote racial understanding. (Courtesy of Blondell Carr Sellers.)

Dr. King's address took place at the Johnson C. Smith University gymnasium. In the group behind Dr. King sits Dr. Reginald Hawkins, a prominent local dentist and nationally known civil rights activist; he was a member of the National Commission on Religion and Race. (Courtesy of Robinson-Spangler Carolina Room, Public Library of Charlotte and Mecklenburg County.)

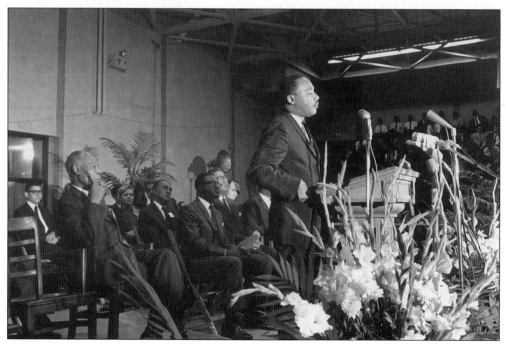

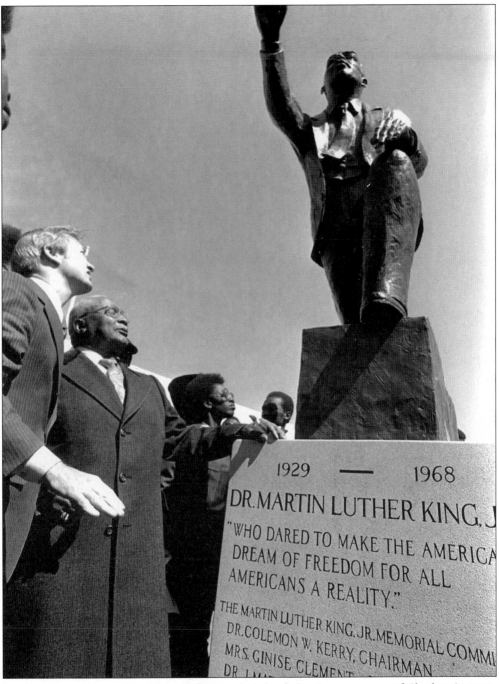

In 1980, then-Governor Jim Hunt (left) attended the dedication ceremony of Charlotte's statue that honors Dr. Martin Luther King Jr. The bronze likeness of Dr. King was created by noted African-American sculptress Selma Burke. Ironically, this tribute to Dr. King stands in Marshall Park, which was developed on land where part of the Second Ward neighborhood—a large, black community that was destroyed in the name of urban renewal—once stood. (Courtesy of Robinson-Spangler Carolina Room, Public Library of Charlotte and Mecklenburg County.)

Shown here in his law office, Julius Chambers won national recognition as the lead attorney for Darius and Vera Swann in their lawsuit seeking a desegregated education for their son, James. Chambers's 1969 victory in the case led to the landmark 1971 U.S. Supreme Court decision that mandated busing to racially balance public schools. As a result of the Swann case and other civil rights activities throughout his career, Chambers endured the bombing of his house and car, the burning of his father's business, and an arsonist's destruction of his law office. Chambers later left Charlotte to become director of the NAACP Legal Defense Fund. (Courtesy of Robinson-Spangler Carolina Room, Public Library of Charlotte and Mecklenburg County.)

The last homecoming queen and the last student body president contemplate the site where Second Ward High School stood before it was closed in 1969 and demolished under urban renewal. Graduates Celesta Shropshire and William McCullough married. Behind them is the headquarters of the Charlotte-Mecklenburg school system. (Courtesy of *The Charlotte Observer.*)

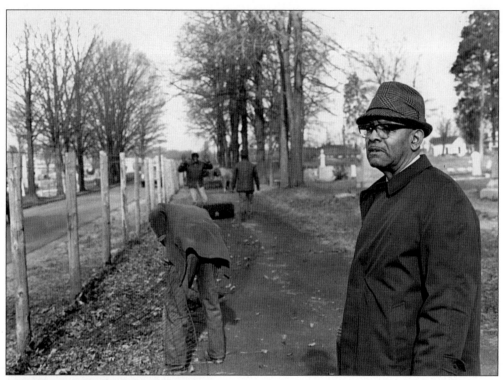

In 1965, Fred Alexander became the first black member of Charlotte City Council elected since Reconstruction. Alexander did much to end municipal practices that promoted segregation, and received national attention for his efforts to remove the fence separating black Pinewood Cemetery from white Elmwood Cemetery. Here, he oversees the removal of the fence that perpetuated segregation, even in death. (Courtesy of Robinson-Spangler Carolina Room, Public Library of Charlotte and Mecklenburg County.)

Harvey Gantt made a name as a civil rights pioneer when in 1963 he became the first black student to gain admission to Clemson University. He then established an architecture practice in Charlotte, won national acclaim for his work, and served on the Charlotte City Council. This photograph shows Gantt celebrating a different accomplishment: in 1983, he was elected as the first African-American mayor of Charlotte. Gantt's victory was a modern-day reminder of the many civic contributions that black citizens have made and continue to make to Charlotte throughout its history. (Courtesy of Robinson-Spangler Carolina Room, Public Library of Charlotte and Mecklenburg County.)